Pro·Lighting

INTERIOR SHOTS

Pro·Lighting

ROGER HICKS and FRANCES SCHULTZ

INTERIOR
SHOTS

ROTOVISION

A Quarto Book

Published and distributed by ROTOVISION SA
Route Suisse 9
CH-1295 Mies
Switzerland
Tel: +41 (22) 755 30 55
Fax: +41 (22) 755 40 72

Distributed to the trade in the United States:
Watson-Guptill Publications
1515 Broadway
New York, NY 10036

ISBN 0-88046-247-9

This book was designed and produced by
Quarto Publishing plc
6 Blundell Street
London N7 9BH

Creative Director: Richard Dewing
Designer: Mark Roberts
Project Editor: Anna Briffa
Picture Researchers: Roger Hicks and Frances Schultz

Typeset in Great Britain by
Central Southern Typesetters, Eastbourne
Manufactured in Singapore by Teck Wah Paper Products Ltd.
Printed in Singapore by ProVision Pte. Ltd.
Tel: +65 334 7720
Fax: +65 334 7721

CONTENTS

▼

THE PRO-LIGHTING SERIES

▼

THE MOST COMMON RESPONSE FROM THE PHOTOGRAPHERS WHO CONTRIBUTED TO THIS BOOK, WHEN THE CONCEPT WAS EXPLAINED TO THEM, WAS "I'D BUY THAT." THE AIM IS SIMPLE: TO CREATE A LIBRARY OF BOOKS, ILLUSTRATED WITH FIRST-CLASS PHOTOGRAPHY FROM ALL AROUND THE WORLD, WHICH SHOW EXACTLY HOW EACH INDIVIDUAL PHOTOGRAPH IN EACH BOOK WAS LIT.

Who will find it useful? Professional photographers, obviously, who are either working in a given field or want to move into a new field. Students, too, who will find that it gives them access to a very much greater range of ideas and inspiration than even the best college can hope to present. Art directors and others in the visual arts will find it a useful reference book, both for ideas and as a means of explaining to photographers exactly what they want done. It will also help them to understand what the photographers are saying to them. And, of course, "pro/am" photographers who are on the cusp between amateur photography and earning money with their cameras will find it invaluable: it not only shows the standards that are required, but also the means of achieving them.

The lighting set-ups in each book vary widely, and embrace many different types of light source: electronic flash, tungsten, HMIs, and light brushes, sometimes mixed with daylight and flames and all kinds of other things. Some are very complex; others are very simple. This variety is very important, both as a source of ideas and inspiration and because each book as a whole has no axe to grind: there is no editorial bias towards one kind of lighting or another, because the pictures were chosen on the basis of impact and (occasionally) on the basis of technical difficulty. Certain subjects are, after all, notoriously difficult to light and can present a challenge even to experienced photographers. Only after the picture selection had been made was there any attempt to understand the lighting set-up.

While the books were being put together, it was however interesting to see how there was often a broad consensus on equipment and techniques within a particular discipline. This was particularly true with the first three books, which were PRODUCT SHOTS, GLAMOUR SHOTS and FOOD SHOTS, but it can also be seen in the second series, of which this forms a part: INTERIORS, LINGERIE and SPECIAL EFFECTS. There is for example a good deal of three-quarter lighting in lingerie, often using soft boxes, and with interiors the most common way to supplement available light was almost invariably with electronic flash, either bounced off the ceiling or in high-mounted umbrellas and soft boxes.

After going through each book – again, with the possible exception of SPECIAL EFFECTS – one can very nearly devise a "universal lighting set-up" which will work for the majority of pictures in a particular speciality, and which needs only to be tinkered with to suit individual requirements. One will also see that there are many other ways of doing things. In SPECIAL EFFECTS there is another factor, which is best summed up as "Good grief! *That's* how they did it!"

The structure of the books is straightforward. After this initial introduction, which changes little among all the books in the series, there is a brief guide and glossary of lighting terms. Then, there is specific introduction to the individual area or areas of photography which are covered by the book. Sub-divisions of each discipline are arranged in chapters, inevitably with a degree of overlap, and each chapter has its own introduction. Finally, at the end of the book, there is a directory of those photographers who have contributed work.

If you would like your work to be considered for inclusion in future books, please write to Quarto Publishing plc, 6 Blundell Street, London N7 9BH, England, and request an Information Pack. DO NOT SEND PICTURES, either with the initial inquiry or with any subsequent correspondence, unless requested; unsolicited pictures may not always be returned. When a book is planned which corresponds with your particular area of expertise, we will contact you. Until then, we hope that you enjoy this book, that you find it useful, and that it helps you in your work.

HOW TO USE THIS BOOK

▼

THE LIGHTING DRAWINGS IN THIS BOOK ARE INTENDED AS A GUIDE TO THE LIGHTING SET-UP RATHER THAN AS ABSOLUTELY ACCURATE DIAGRAMS. PART OF THIS IS DUE TO THE VARIATION IN THE PHOTOGRAPHERS' OWN DRAWINGS, SOME OF WHICH WERE MORE COMPLETE (AND MORE COMPREHENSIBLE) THAN OTHERS, BUT PART OF IT IS ALSO DUE TO THE NEED TO REPRESENT COMPLEX SET-UPS IN A WAY WHICH WOULD NOT BE NEEDLESSLY CONFUSING.

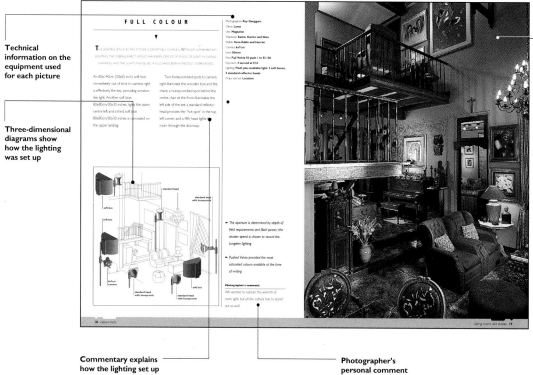

Technical information on the equipment used for each picture

Three-dimensional diagrams show how the lighting was set up

Full page colour picture of the final image

Commentary explains how the lighting set up was approached by the photographer

Photographer's personal comment on his or her picture

Distances and even sizes have been compressed and expanded: and because of the vast variety of sizes of soft boxes, reflectors, bounces and the like, we have settled on a limited range of conventionalized symbols. Sometimes, too, we have reduced the size of big bounces, just to simplify the drawing.

None of this should really matter, however. After all, no photographer works strictly according to rules and preconceptions: there is always room to move this light a little to the left or right,

to move that light closer or further away, and so forth, according to the needs of the shot. Likewise, the precise power of the individual lighting heads or (more important) the lighting ratios are not always given; but again, this is something which can be "fine tuned" by any photographer wishing to reproduce the lighting set-ups in here.

We are however confident that there is more than enough information given about every single shot to merit its inclusion in the book: as well as purely

lighting techniques, there are also all kinds of hints and tips about commercial realities, photographic practicalities, and the way of the world in general.

The book can therefore be used in a number of ways. The most basic, and perhaps the most useful for the beginner, is to study all the technical information concerning a picture which he or she particularly admires, together with the lighting diagrams, and to try to duplicate that shot as far as possible with the equipment available.

A more advanced use for the book is as a problem solver for difficulties you have already encountered: a particular technique of back lighting, say, or of creating a feeling of light and space. And, of course, it can always be used simply as a source of inspiration.

The information for each picture follows the same plan, though some individual headings may be omitted if they were irrelevant or unavailable. The photographer is credited first, then the client, together with the use for which the picture was taken. Next come the other members of the team who worked on the picture: stylists, models, art directors, whoever. Camera and lens come next, followed by film. With film, we have named brands and types, because different films have very different ways of rendering colours and tonal values. Exposure comes next: where the lighting is electronic flash, only the aperture is given, as illumination is of course independent of shutter speed. Next, the lighting equipment is briefly summarized — whether tungsten or flash, and what sort of heads — and finally there is a brief note on props and backgrounds. Often, this last will be obvious from the picture, but in other cases you may be surprised at what has been pressed into service, and how different it looks from its normal role.

The most important part of the book is however the pictures themselves. By studying these, and referring to the lighting diagrams and the text as necessary, you can work out how they were done; and showing how things are done is the brief to which the *Pro Lighting* series was created.

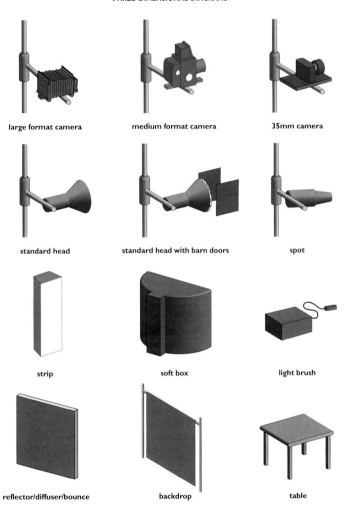

D I A G R A M K E Y

The following is a key to the symbols used in the three-dimensional and plan view diagrams. All commonly used elements such as standard heads, reflectors etc., are listed. Any special or unusual elements involved will be shown on the relevant diagrams themselves.

THREE-DIMENSIONAL DIAGRAMS

large format camera medium format camera 35mm camera

standard head standard head with barn doors spot

strip soft box light brush

reflector/diffuser/bounce backdrop table

PLAN VIEW DIAGRAMS

large format camera medium format camera 35mm camera bounce

gobo

diffuser

standard head standard head with barn doors spot reflector

strip soft box light brush backdrop table

GLOSSARY OF LIGHTING TERMS

▼

Lighting, like any other craft, has its own jargon and slang. Unfortunately, the different terms are not very well standardized, and often the same thing may be described in two or more ways or the same word may be used to mean two or more different things. For example, a sheet of black card, wood, metal or other material which is used to control reflections or shadows may be called a flag, a French flag, a donkey or a gobo — though some people would reserve the term "gobo" for a flag with holes in it, which is also known as a cookie. In this book, we have tried to standardize terms as far as possible. For clarity, a glossary is given below, and the preferred terms used in this book are asterisked.

Acetate
see Gel

Acrylic sheeting
Hard, shiny plastic sheeting, usually methyl methacrylate, used as a diffuser ("opal") or in a range of colours as a background.

***Barn doors**
Adjustable flaps affixed to a lighting head which allow the light to be shaded from a particular part of the subject.

Barn doors

Boom
Extension arm allowing a light to be cantilevered out over a subject.

***Bounce**
A passive reflector, typically white but also, (for example) silver or gold, from which light is bounced back onto the subject. Also used in the compound term "Black Bounce", meaning a flag used to absorb light rather than to cast a shadow.

Continuous lighting
What its name suggests: light which shines continuously instead of being a brief flash.

Contrast
see Lighting ratio

Cookie
see Gobo

***Diffuser**
Translucent material used to diffuse light. Includes tracing paper, scrim, umbrellas, translucent plastics such as Perspex and Plexiglas, and more.

Electronic flash: standard head with parallel snoot (Strobex)

Donkey
see Gobo

Effects light
Neither key nor fill; a small light, usually a spot, used to light a particular part of the subject. A hair light on a model is an example of an effects (or "FX") light.

***Fill**
Extra lights, either from a separate head or from a reflector, which "fills" the shadows and lowers the lighting ratio.

Fish fryer
A small Soft Box.

***Flag**
A rigid sheet of metal, board, foam-core or other material which is used to absorb light or to create a shadow. Many flags are painted black on one side and white (or brushed silver) on the other, so that they can be used either as flags or as reflectors.

***Flat**
A large Bounce, often made of a thick sheet of expanded polystyrene or foam-core (for lightness).

Foil
see Gel

French flag
see Flag

Frost
see Diffuser

***Gel**
Transparent or (more rarely) translucent coloured material used to modify the colour of a light. It is an abbreviation of "gelatine (filter)", though most modern "gels" for lighting use are actually of acetate.

***Gobo**
As used in this book, synonymous with "cookie": a flag with cut-outs in it, to cast interestingly-shaped shadows. Also used in projection spots.

"Cookies" or "gobos" for projection spotlight (Photon Beard)

***Head**
Light source, whether continuous or flash. A "standard head" is fitted with a plain reflector.

***HMI**
Rapidly-pulsed and

effectively continuous light source approximating to daylight and running far cooler than tungsten. Relatively new at the time of writing, and still very expensive.

***Honeycomb**

Grid of open-ended hexagonal cells, closely resembling a honeycomb. Increases directionality of

Honeycomb (Hensel)

light from any head.

Incandescent lighting

see Tungsten

Inky dinky

Small tungsten spot.

***Key or key light**

The dominant or principal light, the light which casts the shadows.

Kill Spill

Large flat used to block spill.

***Light brush**

Light source "piped" through fibre-optic lead. Can be used to add highlights, delete shadows and modify lighting, literally by "painting with light".

Electronic Flash: light brush "pencil" (Hensel)

Electronic Flash: light brush "hose" (Hensel)

Lighting ratio

The ratio of the key to the fill, as measured with an incident light meter. A high lighting ratio (8:1 or above) is very contrasty, especially in colour, a low lighting ratio (4:1 or less) is flatter or softer. A 1:1 lighting ratio is completely even, all over the subject.

***Mirror**

Exactly what its name suggests. The only reason for mentioning it here is that reflectors are rarely mirrors, because mirrors create "hot spots" while reflectors diffuse light. Mirrors (especially small shaving mirrors) are however widely used, almost in the same way as effects lights.

Northlight

see Soft Box

Perspex

Brand name for acrylic sheeting.

Plexiglas

Brand name for acrylic sheeting.

***Projection spot**

Flash or tungsten head with projection optics for casting a clear image of a gobo or cookie. Used to create textured lighting effects and shadows.

***Reflector**

Either a dish-shaped

surround to a light, or a bounce.

***Scrim**

Heat-resistant fabric

Electronic Flash: projection spotlight (Strobex)

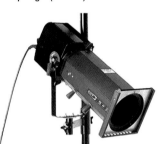

Tungsten Projection spotlight (Photon Beard)

diffuser, used to soften lighting.

***Snoot**

Conical restrictor, fitting over a lighting head. The light can only escape from the small hole in the end, and is

therefore very directional.

***Soft box**

Large, diffuse light source made by shining a light

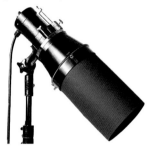

Tungsten spot with conical snoot (Photon Beard)

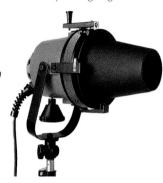

Electronic Flash: standard head with parallel snoot (Strobex)

through one or two layers of diffuser. Soft boxes come in all kinds of shapes

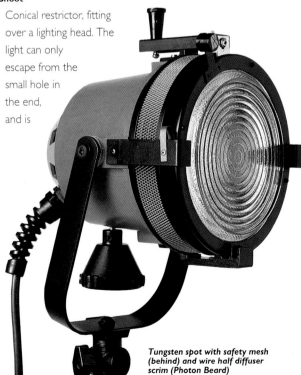

Tungsten spot with safety mesh (behind) and wire half diffuser scrim (Photon Beard)

Electronic flash: standard head with large reflector and diffuser (Strobex)

and sizes, from about 30x30cm to 120x180cm and larger. Some soft boxes are rigid; others are made of fabric stiffened with poles resembling fibreglass fishing rods. Also known as a northlight or a windowlight, though these can also be created by shining standard heads through large (120x180cm or larger) diffusers.

***Spill**

Light from any source which ends up other than on the subject at which it is pointed. Spill may be used to provide fill, or to light backgrounds, or it may be controlled with flags, barn doors, gobos etc.

***Spot**

Directional light source. Normally refers to a light using a focusing system

with reflectors or lenses or both, a "focusing spot", but also loosely used as a reflector head rendered more directional with a honeycomb.

***Strip or strip light**

Lighting head, usually flash, which is much longer than it is wide.

Electronic flash: strip light with removable barn doors (Strobex)

Strobe

Electronic flash. Strictly, a "strobe" is a stroboscope or rapidly repeating light source, though it is also the name of a leading manufacturer.

Tungsten spot with removable Fresnel lens. The knob at the bottom varies the width of the beam (Photon Beard)

Strobex, formerly Strobe Equipment.

Swimming pool

A very large Soft Box.

***Tungsten**

Incandescent lighting. Photographic tungsten

Electronic flash: standard head with standard reflector (Strobex)

lighting runs at 3200°K or 3400°K, as compared with domestic lamps which run at 2400°K to 2800°K or thereabouts.

***Umbrella**

Exactly what its name suggests; used for modifying light.

Umbrellas may be used as reflectors (light shining into the umbrella) or diffusers (light shining through the umbrella). The cheapest way of creating a large, soft light source.

Windowlight

Apart from the obvious meaning of light through a window, or of light shone through a diffuser to look as if it is coming through a window, this is another name for a soft box.

Tungsten spot with shoot-through umbrella (Photon Beard)

INTERIOR SHOTS

▼

THE DEMAND FOR PHOTOGRAPHS OF INTERIORS IS IMMENSE. HOTELS, BARS AND RESTAURANTS WANT BROCHURES. MAGAZINES OF ALL KINDS WANT TO SHOW OFF THE HOUSES OF THE RICH AND FAMOUS OR SIMPLY TO GIVE PEOPLE IDEAS ABOUT HOW TO DECORATE AND REMODEL THEIR OWN HOMES. TOURIST ATTRACTIONS SUCH AS STATELY HOMES AND ANCIENT MANSIONS NEED TO ADVERTISE — AND THERE ARE WHOLE BOOKS ON HISTORIC BUILDINGS. SHOPS AND OFFICES WANT PHOTOGRAPHS, EITHER FOR ADVERTISING OR SIMPLY AS A RECORD. ARCHITECTS WANT TO SHOW HOW THEIR TALENTS ARE REALIZED. AND MANUFACTURERS OF ALL KINDS OF GOODS WANT TO ADVERTISE THEIR WARES: FURNITURE (ESPECIALLY BEDS AND BEDDING), FITTED KITCHENS, KITCHEN APPLIANCES, HI-FIS, CARPETS, WALLPAPER, FURNISHING FABRICS. THE LIST GOES ON AND ON.

Normally, what the client wants is a picture which looks "straight." In other words, they want it as close as possible to the way that the human eye sees a scene and (more important still) to the way that the human brain remembers it. The two problems which the photographer soon discovers are, firstly, that most rooms are not arranged the way we remember them, and, secondly, the way that they are lit is often even further from our mental image. They are untidy; there are large areas of blank wall and blank floor; and all too often, if we try to shoot them without controlled lighting, the overall effect is either one of pools of light in general darkness, or of burned-out lights and windows in a more or less correctly exposed room.

The most basic problems of untidiness derive from the fact that the vast majority of rooms are designed to be lived in, rather than to be photographed. Even if they are "tidy" in the conventional sense, they may well have electric wall sockets in the wrong places; mirrors, or the glass in picture frames, may catch awkward reflections from certain angles; and the layout of the furniture is unlikely to be ideal, so a

certain amount of "gardening" is likely to be required.

To compound this, there is always a fine balance between sterility and an excessively lived-in appearance. There is a world of difference between a single newspaper lying on a table, or a handful of magazines artfully arranged, and the kind of untidy stack which can so rapidly accumulate and consists (for example) of a half-read book, yesterday's papers, the television listings, a telephone directory and a couple of not-very-important letters which were opened, glanced at, and then forgotten about when the telephone rang.

The blank areas of wall and floor are often a harder problem to address, and often the only possibility is to change the viewpoint. Sometimes, though, it is possible to improve matters greatly by moving rugs on the floor, or by using furniture (and especially standard lamps) to break up awkward areas of wall.

The problems with uneven lighting derive principally from the limited range of tones which film can record — and from the fact that ordinary room lighting normally covers a much wider range. The dramatic interplay of light and shade is,

however, often one of the most attractive features of an interior – and an architect or designer is unlikely to be very happy if you destroy the balance of light and shade which was originally intended. Also, lighting that is too flat will often look unnatural, like a stage set or television scene. The art of lighting interiors is for the most part the art of retaining the original patterns of light and shade, while bringing the total tonal range within what can be accommodated on film. More rarely, but still in a significant number of cases, the photographer must emphasize products such as kitchen cabinets which would normally not be give a second glance.

THE PURPOSE OF INTERIOR PHOTOGRAPHY

A good question for any commercial photographer is "What are you trying to sell?" The answer may be a tangible item, such as a bathroom suite or a range of wallpapers; or the use of a place or the idea of visiting it, such as a restaurant or a stately home; or an idea, such as a particular style of furnishing. Only rarely is the photograph itself the thing that is being sold, except indirectly (that is, to a

client who is trying to sell his wallpaper or his hotel rooms or whatever), though there is a modest market for beautiful pictures of beautiful interiors. Mostly, these sell in the form of books, though there is the possibility of selling original prints, posters and of course postcards.

LOCATIONS AND ROOM SETS

The majority of the pictures in this book – and indeed, the majority of all interiors – are location shots, and locations often impose their own logic on lighting. Sometimes the photographer may have to light adjacent rooms, to prevent doorways from reading as "black holes", and it is not unusual to have to light through a doorway or even through a window, with the flash unit out of doors.

The normal approach on location is to determine the exposure on the basis of available light, and then to add supplementary lighting as necessary. Often, quite small apertures are the order of the day, simply to get the required depth of field, and exposures of several seconds are the norm. This is why relatively few interiors feature people. Flash (the normal medium for supplementary lighting) is typically used one to three stops down from the available light.

With room sets, the photographer obviously has more control but truly impressive amounts of light are often needed. It is quite unusual to shoot a location without using at least some available light (though there are examples of this sort of picture in the book), but in a room set all the light must normally be supplied. As a result, many photographers of room sets rely on

tungsten lighting and long exposures.

If you want people in shot, the only options in most cases are to use roll film instead of 4x5 inch or to use fully controlled lighting (i.e. without relying at all on available light) and to use impressive quantities of flash: 10,000 watt-seconds is by no means unusual.

CAMERAS AND LIGHTING EQUIPMENT FOR INTERIOR SHOTS

Overwhelmingly the most popular film size for shooting interiors is 4x5 inch, principally because of the availability of camera movements (especially the rising front) but also because a good, large Polaroid test picture makes for considerable peace of mind. The use of 8x10 inch is normally limited to built room sets, while some photographers favour roll-film cameras for what might loosely be termed "lifestyle" shots: the extra depth of field available on the smaller formats can be very welcome. Only very rarely is 35mm used.

Perhaps surprisingly, extreme wide angles are little used either. Although the 47mm XL Super-Angulon covers 4x5 inch and permits a modest degree of movement, and 58mm on 4x5 inch is quite feasible, even 65mm shots are rare on these pages and 90mm is the widest that many interior photographers like to work with. Most successful interior photographers agree that as a rule, you should always use the longest lens you can, rather than the widest.

As for lighting equipment, the principal consideration is generally portability, which means that monoblock heads are the normal winners, though some photographers prefer separate

power packs and heads. Because of the large areas which often have to be lit, power is also important, another argument for separate packs and heads; 2400 watt-seconds through a single head is readily obtainable in this way, while 1200 watt-seconds is the normal limit for monoblocks. At the other extreme, some photographers use tiny self-contained slave units, with as little as 30 watt-seconds, to light up small areas.

Most photographers use plain reflector heads and bounce the light off walls or ceilings, though when there is a risk of colour casts it is better to use umbrellas or reflectors. Soft boxes are relatively little used, though there are times when they are all but essential. Another useful tool is a dome diffuser, a plastic hemisphere which gives remarkably even lighting over 180° and sometimes more. They really come into their own for very small interiors.

Quite a common problem is the availability of sufficient power supplies for tungsten or flash lighting: the initial current draw of even a 1200 watt-second flash unit can be 4-5 amps on a 220-240 volt circuit of 8-10 amps on 110 volts. Although one pack should not be a problem, and two packs should be all right, trying to run three packs off the same socket may be pushing your luck.

If this is a problem, there are several solutions. One is obviously a generator; another is powerful battery equipment such as is made by Hensel; a third is a "Magic Bus" which charges standard studio heads sequentially (a more difficult electronic trick than is immediately apparent); and a fourth is big, old-fashioned flash bulbs, which were at the

time of writing still available. A single expendable PF60 bulb delivers more power than a 1200 watt-second flash head, and it is often cheaper, quicker, lighter and easier to use big bulbs than to hire specialist equipment.

LOGISTICS AND PROPS

Because so much interior photography is done on location, arguably the most essential tool is the check list for lights, cameras, lenses, film, etc. Props are normally less of a problem, as they can almost invariably be garnered from the location itself. As already discussed above, the main concern of the photographer is normally "gardening" the props, either simplifying overly cluttered surfaces or breaking up dull expanses by importing props from elsewhere in the room or building – or sometimes both.

Props are normally less of a problem on location, as they can almost invariably be garnered from the location itself. As already discussed above, the main concern of the photographer is normally "gardening" the props, either simplifying overly cluttered surfaces or breaking up dull expanses by importing props from elsewhere in the room or building – or sometimes both.

THE TEAM

Most interior photographers work alone. Shooting interiors on 4x5 inch is normally a slow and reflective process, where the photographer has enough time to move things about himself or herself, and there is no great need for assistants; or to be more accurate, the need for them is not great enough to warrant the expense of hiring them. Shooting interiors on roll film is often more akin to reportage, and once again there is no great need for an assistant.

With built sets things are often quite different. In addition to the set-builders themselves, there may be stylists, interior decorators, art directors and quite often the client as well. Also, because of the complexity and quantity of lighting used, it is common to work with an assistant.

THE INTERIOR SHOOT

Normally, the photographer must make at least two visits to the location to be photographed. The first is a straightforward scouting trip, to get an idea of the size of the place, the optimum viewpoint, and the amount of supplementary lighting which will be required: to carry half a ton of lighting on the off-chance that it might be needed is not the most convenient way to work. A compact camera can be extremely useful for reference pictures: a 28mm lens on a 35mm camera is roughly equivalent to a 90mm on 4x5 inch, and some of the better compacts have 28-90mm zooms. It is often as well to shoot one picture from the proposed viewpoint, and then a series of other pictures from the centre of the space so that the whole room is covered.

On this scouting trip the photographer can also gauge what might be the best time of day to shoot; obviously, available light will vary broadly across the day according to the direction in which the windows face. Sometimes it is imposssbile to shoot at the best time of day – you just have to shoot when the client lets you in – but at other times it may be essential to shoot under particular lighting conditions, especially if there are big windows or even semi-open conditions as when photographing swimming pools.

As already suggested, another thing to check during the scouting trip is the availability and location of power points: churches, in particular, often have negligible numbers of power points and the wiring may be so old that the plug sockets are non-standard. Often, adequate scouting can be accomplished in a few minutes, but it helps to have a check-list to make sure that you have looked at everything necessary.

The main thing about the second or shooting trip is time; the perennial problem is the client who knows that it takes only a fraction of a second to take a picture, because he has taken thousands of pictures himself. Of course he allows the professional photographer a bit more time – but surely ten minutes should be enough, and an hour should be more than sufficient? Ideally, you should be able to shoot test pictures and have them processed; but if you can't, then plenty of Polaroids and a couple of spare exposures are always a great comfort. Truly paranoid photographers may well shoot six or eight' chromes: four at the "correct" exposure, one or two at a stop over and one or two at a stop under. Combined with "push" and "pull" processing, this enables you to get the perfect exposure over a four-stop range. The alternative is to shoot negative film; one photographer whose work appears in this book reckons that he has never yet failed to get the shot he wanted on his first sheet of negative film, though he always shoots a back-up sheet as a precaution.

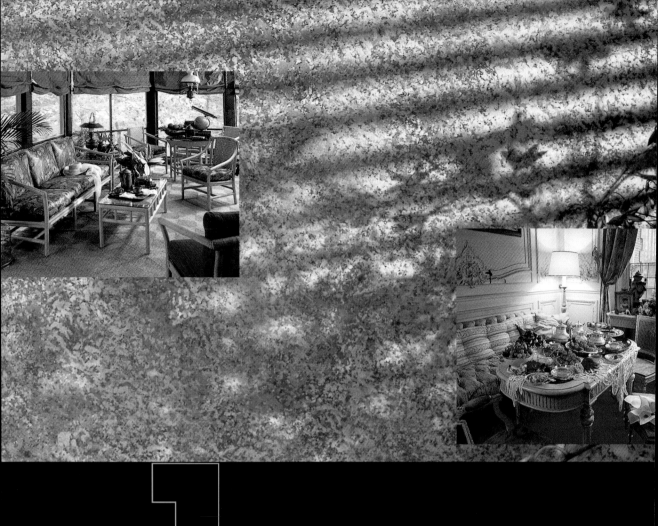

1

sitting rooms and
studies

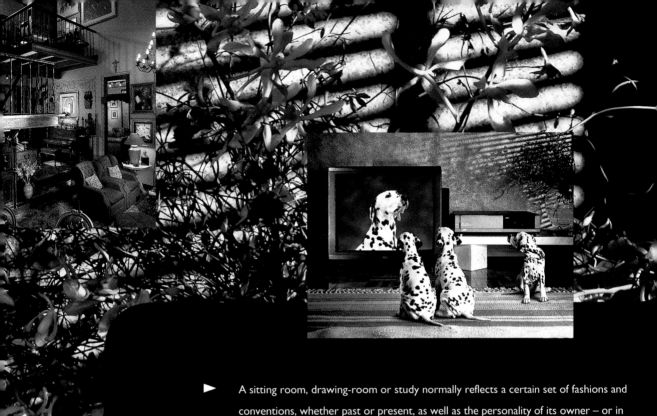

A sitting room, drawing-room or study normally reflects a certain set of fashions and conventions, whether past or present, as well as the personality of its owner – or in the case of advertising photography, the personality of the kind of people that the advertiser hopes will want to be an owner. Photography of such interiors is therefore likely to be more formal than the photography of other domestic interiors and naturalism is less important: fewer books, magazines, knick-knacks and other props are generally used.

This does not mean, however, that there is no risk of sterility: a besetting problem of pictures of sitting rooms and studies is that they look too much like room-sets or advertisements for furniture. There must be enough variety to create mood and context, which cannot be achieved (no matter what the advertisers might hope) by merely buying a particular range of furniture or fabrics.

As for the actual lighting, this may vary from entirely natural lighting to the most elaborate lighting plots and even to built sets and composited images, but the usual approach is to use comparatively modest amounts of electronic flash to supplement the available light, and to balance the available light to the flash by juggling aperture and shutter speed. Flash exposure, of course, is affected solely by aperture while exposure by ambient light is also affected by shutter speed.

FULL COLOUR

▼

THE LIGHTING SET-UP IN THIS PICTURE IS DECEPTIVELY COMPLEX. WITHOUT SUPPLEMENTARY LIGHTING, THE OVERALL EFFECT WOULD HAVE BEEN ONE OF OF POOLS OF LIGHT IN OVERALL DARKNESS, AND THE LIGHTS THEMSELVES WOULD HAVE BEEN HOPELESSLY OVEREXPOSED.

An 80x140cm (30x55 inch) soft box immediately out of shot to camera right is effectively the key, providing window-like light. Another soft box, 80x80cm/30x30 inches, lights the piano centre left and a third soft box 80x80cm/30x30 inches is concealed on the upper landing.

Two honeycombed spots to camera right illuminate the wooden box and the chairs; a honeycombed spot behind the centre chair at the front illuminates the left side of the set; a standard reflector head provides the "hot spot" in the top left corner; and a fifth head lights the room through the doorway.

Photographer: **Roy Genggam**

Client: **Laras**

Use: **Magazine**

Assistants: **Santo, Kamto and Gino**

Stylists: **Erna Eddin and Herrini**

Camera: **6x7cm**

Lens: **50mm**

Film: **Fuji Velvia 50 push 1 to EI 100**

Exposure: **4 second at f/16**

Lighting: **Flash plus available light: 3 soft boxes, 5 standard reflector heads**

Props and set: **Location**

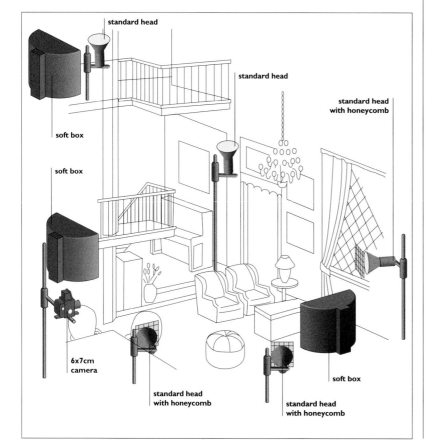

standard head

standard head

standard head with honeycomb

soft box

soft box

6x7cm camera

standard head with honeycomb

standard head with honeycomb

soft box

► The aperture is determined by depth of field requirements and flash power; the shutter speed is chosen to record the tungsten lighting

► Pushed Velvia provided the most saturated colours available at the time of writing

Photographer's comment:

We wanted to capture the warmth of room light, but all the colours had to stand out as well.

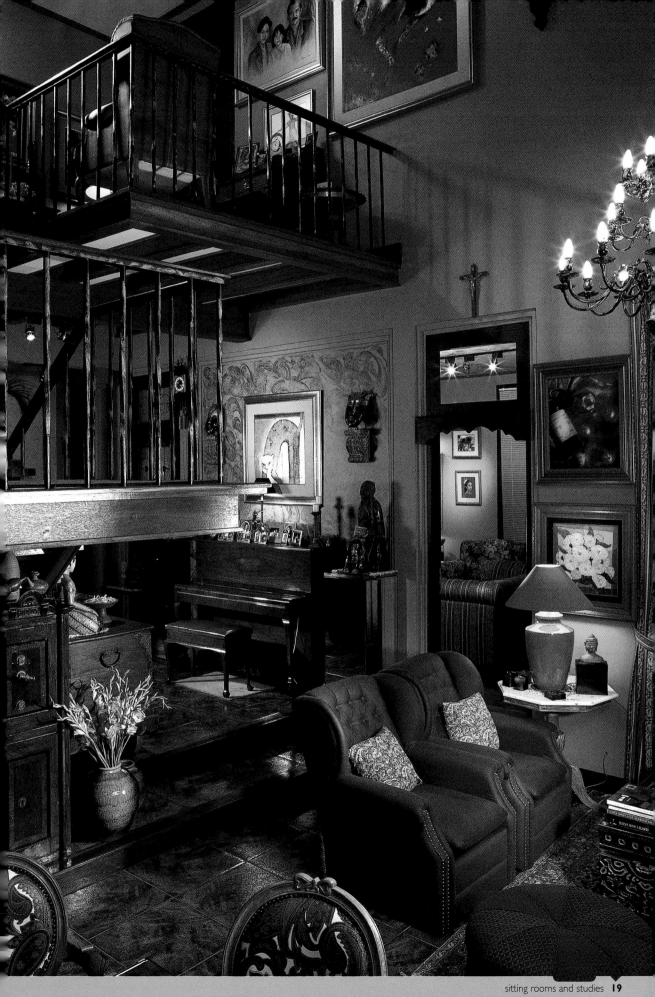

LIVING ROOM

▼

Photographer: **George Solomonides**

Client: **Residential Holdings plc**

Use: **Letting/selling brochure**

Camera: **4x5 inch**

Lens: **65mm**

Film: **Kodak Ektachrome 64 6117**

Exposure: **f/22**

Lighting: **Electronic flash: 4 heads**

CLEARLY IT IS IMPORTANT TO BALANCE THE INTERIOR LIGHTING TO THE EXTERIOR, WITHOUT OVERWHELMING THE WINDOWLIGHT; BUT IT IS AT LEAST EQUALLY AS IMPORTANT TO MAKE THE INTERIOR LOOK WARM AND WELCOMING AS COMPARED WITH THE WEATHER OUTSIDE.

There are four flash heads, two on either side of the camera and close to the wall, pointing straight upwards. The light is therefore bounced partly from the wall and partly from the ceiling to provide a warm fill to balance the rather cold light of day. Also, somewhat overexposing the scene outside the window reduces the impact of the flats across the way. The overall golden colour of the decor warms up the light sufficiently, without any additional filtration having to be used. Because the light from the bounced flash is very diffuse and does not cast shadows, the lighting ratio between it and the highly directional light from the window can be very tight; and as usual, the photographer can take advantage of the fact that the flash exposure is affected only by aperture, so the daylight exposure can be independently varied by changing the shutter speed.

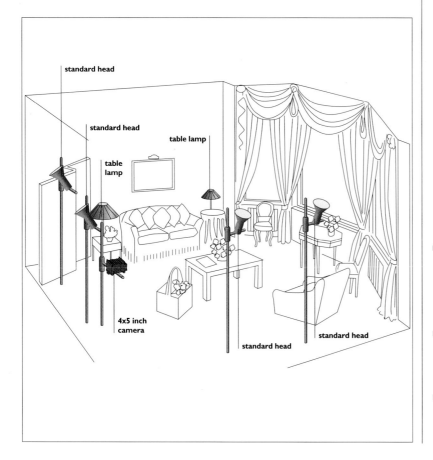

standard head

standard head

table lamp

table lamp

4x5 inch camera

standard head

standard head

► The way in which painted walls colour light that is bounced from them can sometimes be turned to advantage

► Over- or underexpose exteriors if you do not want them to "read" too clearly

► Very diffuse light will not cast shadows when it is used to fill against directional light even of only slightly higher intensity

FOUR DALMATIANS

▼

THIS IS A COMPOSITE OF FOUR SHOTS, ALL OF THE SAME SET. THE FIRST IS AN 8X10 INCH SHOT OF THE PRINCIPAL SET, WITHOUT THE DOGS. THE OTHERS ARE 6X6CM SHOTS OF THE DOGS, ON SET, AND A PORTRAIT OF THE DOG ON THE TELEVISION.

Photographer: **Jay Myrdal**

Client: **Demond Advertising for JVC**

Use: **National press**

Assistant: **Bill Diaz**

Art directors: **Jeremy Paine, Andy Plumi, Frank Tyson**

Camera: **8x10 inch and 6x6cm**

Lens: **300mm and CC10M (8x10 inch) and 250mm (6x6cm)**

Film: **Kodak Ektachrome 64**

Exposure: **f/45 (8x10 inch); 6x6cm not recorded**

Lighting: **Flash and exposure for other lights (see text)**

Props and set: **Built set; prop table**

This allowed a choice of dog shots – and because the dogs are a small part of the overall image, they could be shot on 6x6cm and still remain in proportion to the 8x10 inch image area. The photocomposition was by traditional retouching methods, not electronic.

The lighting was the same in all three shots, as drawn: two spots to camera left to create edge definition on the television, a projection spot to camera right for the "venetian blind", a blue focusing spot immediately to camera right to illuminate the main product, and a "flooter" reflected from a foil also to camera right. Overall fill came from an overhead soft box.

Because some of the heads were quite low powered, numerous "hits" were used for the main shot, plus 5 minutes for the video panel and 2½ minutes for the screen. The dog shots – one of the group, one of the lone dog, and one of the "father dog" on television – were of course single hits at a much wider aperture on 6x6cm.

► If picture elements are to be combined in cutouts, it often makes sense to shoot them on set so that they are oriented correctly

► Dropping cutouts from 6x6cm images into 8x10 inch images may seem eccentric, but if the right focal lengths are used the perspective can remain consistent

► Using the same film stock for different picture elements minimizes problems with matching colours, grain etc.

Photographer's comment:

The dogs were shot from a slightly lower angle and scaled slightly smaller in the photocomp than they were in real life; we could not get pups the right size.

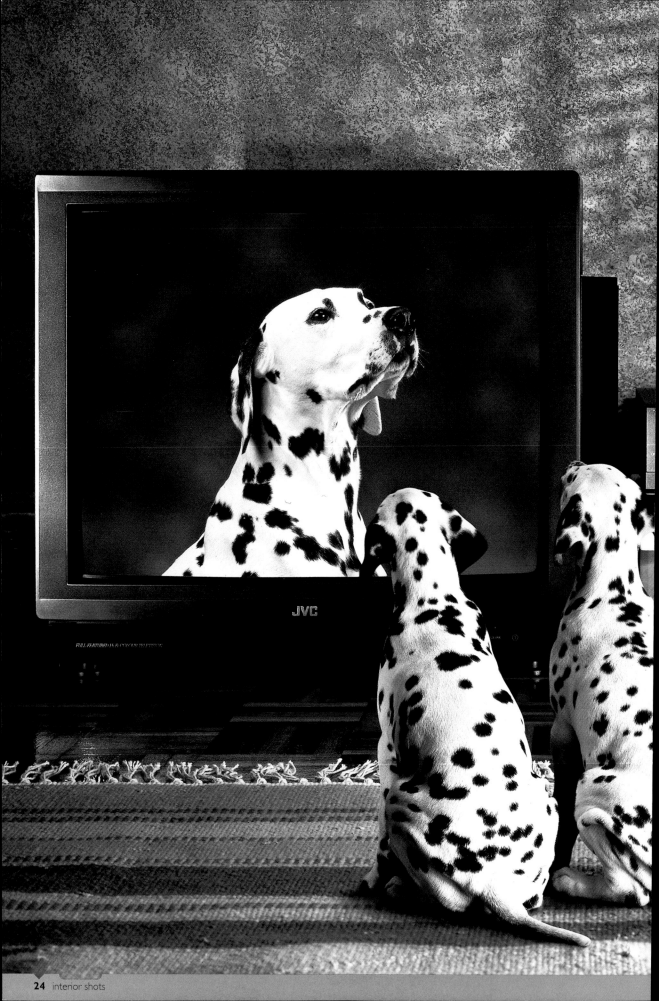

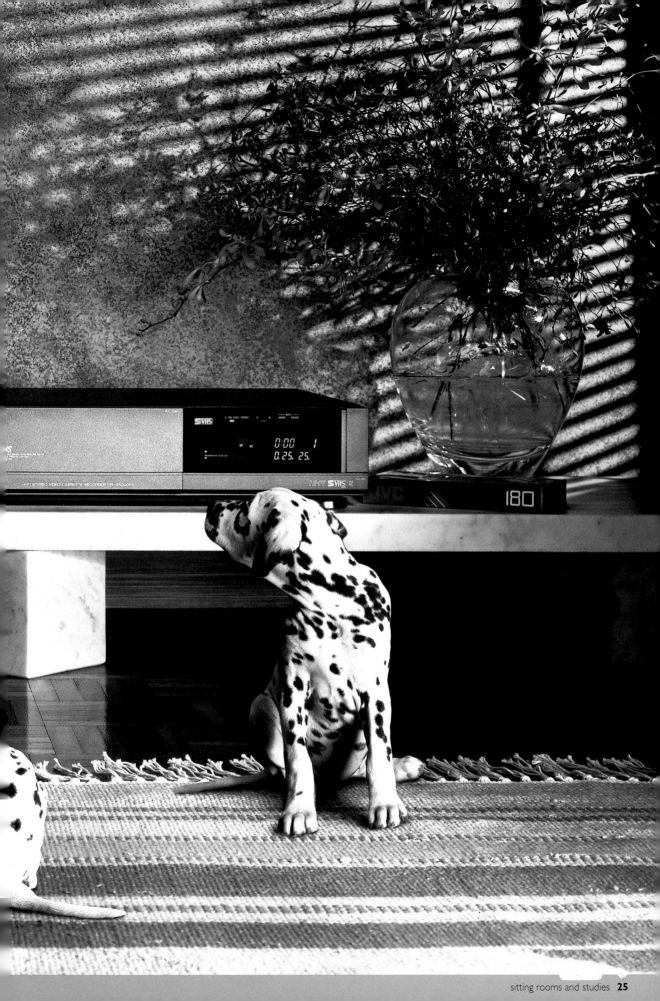

TEA IN THE DRAWING ROOM

▼

Photographers: **Michel de Meyer and Max Schneider**

Client: **Proeven**

Use: **Editorial**

Assistants: **Filip Thirion and Christine Struye**

Art director: **Leonce Bihet**

Stylist: **Tania Janssens**

Camera: **6x6cm**

Lens: **80mm**

Film: **Kodak Ektachrome 100 Plus (EPP)**

Exposure: **Long exposure (not recorded) at f/16**

Lighting: **Mixed — see text**

Props and set: **Castle interior with rented props**

THE KEY LIGHT IS CLEARLY THE DAYLIGHT FROM THE WINDOW, BUT IT IS SUPPLEMENTED BY A LARGE SOFT BOX TO CAMERA LEFT, WHICH ACTS AS A FILL, AND BY THE EXISTING TUNGSTEN LIGHT IN THE CORNER OF THE ROOM.

The balance between different kinds of available light – in this case, the window and from the large lamp – can be adjusted in a number of ways, not least by a "split" exposure with the electric lamp lit for only part of the exposure. Here, Michel de Meyer and Max Schneider decided to allow the electric lamp the role which it has in the real room, namely to be a principal light source. It is there, after all, because the room would be rather dark without it. In order to supplement the windowlight and to stop the picture from being too yellow, however, they added a soft box to camera right, just out of shot beside the window.

This photograph also illustrates the use of an interior to set a mood: the real purpose of the picture is a food shot, but the aim is to create an atmosphere of affluence around the food.

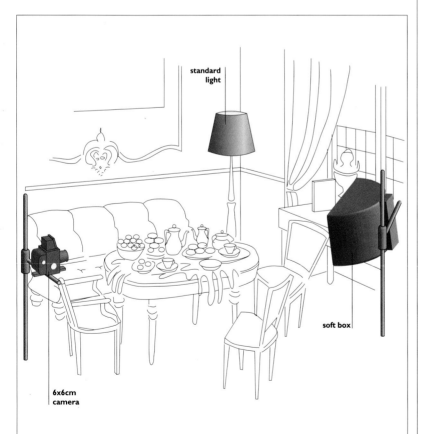

standard light

soft box

6x6cm camera

► *Net curtains and window drapes can cut light to a surprising extent*

► *It often looks more natural to supplement daylight with a soft box than to open the curtains*

Photographer's comment:

The Chateau de Louvignies where this was shot can be rented for stills and movie photography. Contact Mme. B. Moreau on 02 771 08 95.

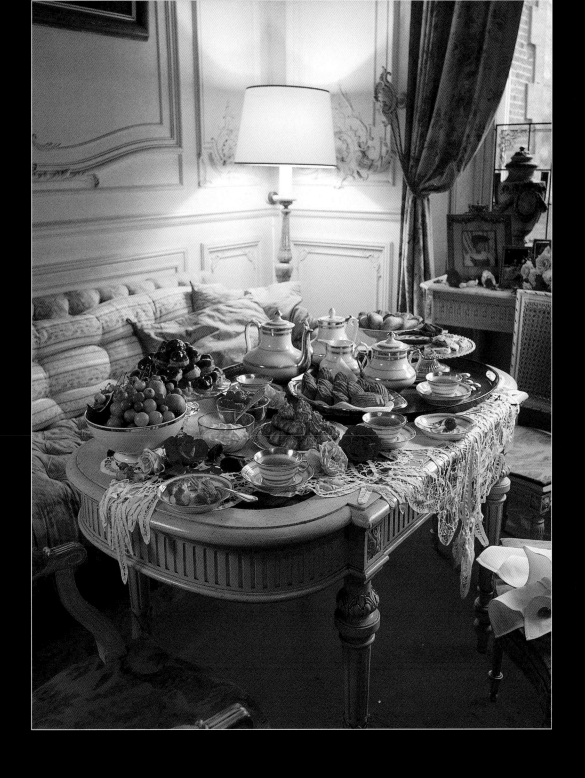

STURDIVANT HOUSE

▼

OLD-FASHIONED WOODEN SHUTTERS HAD TWO USES. ONE WAS SECURITY; THE OTHER WAS TO DIFFUSE AND MELLOW THE LIGHT COMING INTO THE ROOM IN BRIGHT, SUNNY CLIMATES. THE PHOTOGRAPHER MAY FIND THEM USEFUL FOR THE SECOND PURPOSE.

Photographer: **Roger W. Hicks**

Client: **BLA Books**

Use: **Editorial (book)**

Camera: **35mm**

Lens: **14mm**

Film: **Fuji 100**

Exposure: **1/4 second at f/11**

Lighting: **Daylight through shutters**

Props and set: **Location: Sturdivant House, Selma AL**

Without the shutters drawn, the light in this room would have been harsh and too strongly directional. It might seem that the obvious approach would have been to close the shutters only on the sunny side of the house, but in fact this merely reverses the problem, with the unshuttered windows burning out.

Perhaps surprisingly, the best solution was to shutter all the windows, even the ones that are out of shot.

Because the picture was to be reproduced quite small in a book (10x15cm, 4x6 inches), 35mm was adequate. Also, the immense depth of field of a 14mm lens on 35mm was useful.

sunlight

35mm camera

► Faster films generally have greater latitude than slower ones – hence ISO 100 rather than ISO 50

► Always consider the possibilities of shutters, curtains and drapes as light modifiers

► Short-focus lenses on smaller formats can replace movements on larger cameras

SUN LOUNGE

▼

It was important to show the accurate shape and colour of the furniture while still creating the impression of sunlight streaming in. This was accomplished with two standard heads bounced from reflectors at floor level and a diffused head to camera right.

Photographer: **Tim Edwards**

Client: **Alderman Co.**

Use: **Record/editorial**

Camera: **4x5 inch**

Lens: **90mm**

Film: **Fuji RDP ISO 100**

Exposure: **6 seconds at f/22**

Lighting: **Available light plus electronic flash: 3 heads**

Props and set: **Location**

There is some evidence of crossed shadows – look at the nearest leg of the sofa and the two legs of the table – but this is far less important than usual in a sun lounge, where the very idea is to convey light from all directions. The supplementary lighting was used, in effect, to create the illusion of extra windows. There was no need to filter the flash, which is more blue than sunlight, because we expect sunlight to predominate from one direction and sky light from the other; the flash is somewhere between the two, but nearer to sky light than to warm sunlight. The working aperture of f/22 was dictated principally by depth of field requirements, and the shutter speed was set to suit this. Even allowing for the way that the floor-level flash can be used a stop or more down from this, you still need quite powerful flash units to light this much space.

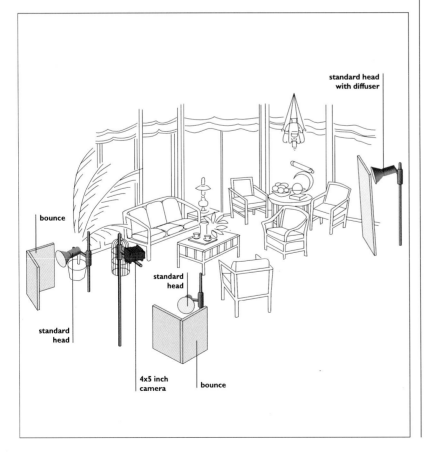

standard head with diffuser

bounce

standard head

standard head

4x5 inch camera

bounce

► Flash equates closer to cool daylight than to warm sunlight

► A 120mm lens is not so wide on 4x5 inch that it causes unacceptable distortions

► Crossed shadows, normally a cardinal sin, may not matter in a sun room where light is supposed to come from all directions

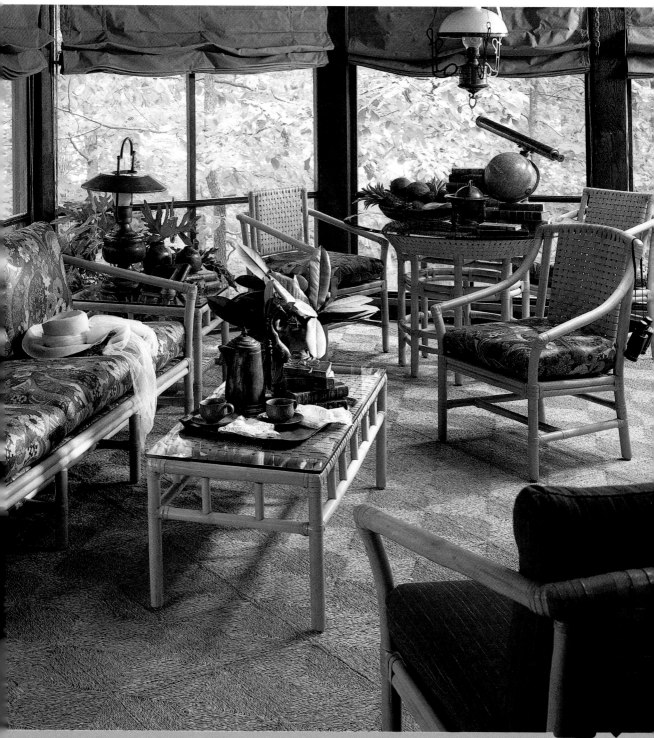

S T U D Y

▼

IT IS SURPRISING HOW OFTEN IT IS POSSIBLE TO WORK ONLY WITH AVAILABLE LIGHTING — ESPECIALLY IF YOU CAN TURN TUNGSTEN LIGHTS ON AND OFF INDEPENDENTLY, AND VARY BULB WATTAGES AS NEEDED. LIGHT FLOORS AND DRAPED WINDOWS ARE A HELP, TOO.

The main light sources are clearly the window and (still more strongly) the door to the right; although the light through the door to the right is entirely natural, it could if necessary have been duplicated with bounce flash.

Because the main light is daylight, it is natural to use daylight-balance film. The additional tungsten lighting, especially above the bookcases, reads "warm" but this is not a problem in a predominantly light-toned image. In a darker room, where less of the daylight is bounced around, the tungsten and daylight might not blend so happily.

Photographer: **Tim Edwards**, Client: **Christina Fallah**, Use: **Record/editorial**, Camera: **4x5 inch** Lens: **90mm**, Film: **Fuji RDP ISO 100** , Exposure: **6 seconds at f/22-1/2,** Lighting: **Available light** Props and set: **Location**

Photographer's comment:

The use of various tungsten sources in the room added light and warmth.

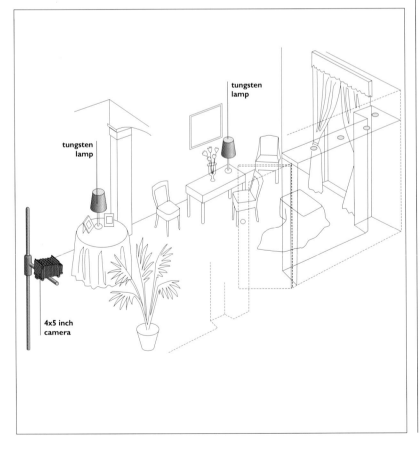

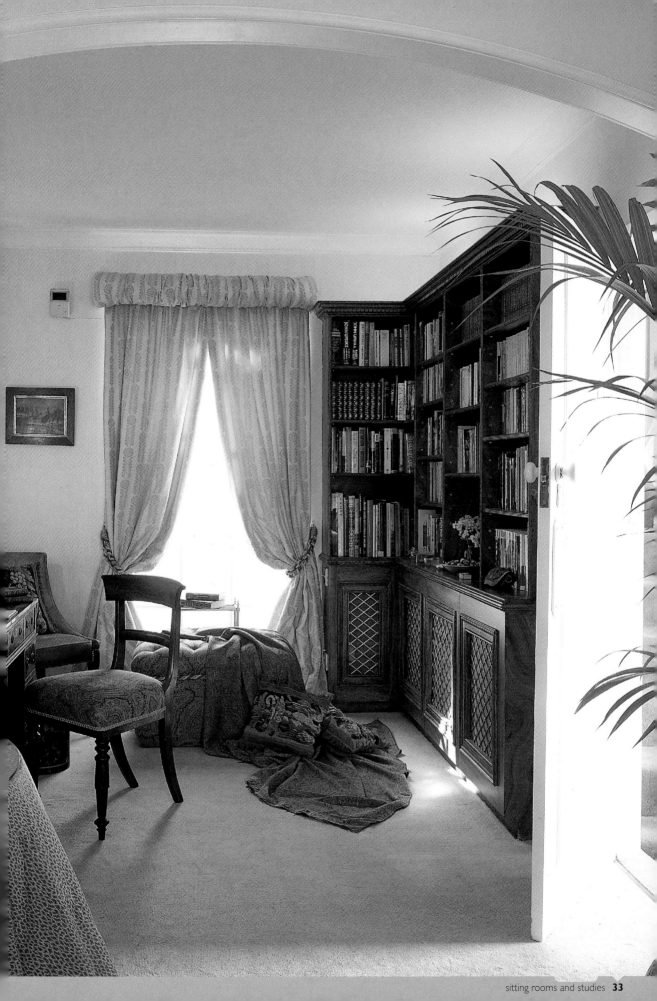

2 bedrooms and
bathrooms

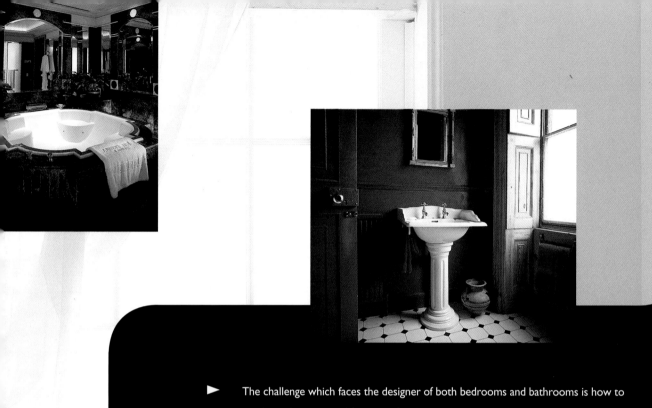

The challenge which faces the designer of both bedrooms and bathrooms is how to combine character and function. On the one hand the bed, and on the other the bathroom fitments, impose their own logic on the room.

The photographer can be still more challenged. A bedroom consisting mostly of a bed is seldom an attractive picture, the more so if the broad expanse of a large bed is unbroken by pillows, throws or whatever. In a bathroom, there are lots of hard-edged reflective surfaces, and there may also be a very high contrast range; Thomas George Epperson's picture illustrates both of these points.

To a large extent, props and viewpoint can overcome some of these difficulties, but there is also a great deal which can be done with lighting – and often, a surprising number of lights are used in photographing bathrooms and bedrooms, far more than you would expect given the size of the rooms or sets.

As ever, the lighting must look natural, and (again as ever) what looks natural may not be the same as what is natural. Quite high degrees of chiaroscuro may be used, as in Riva, but even so the photographer must exercise considerable care to make sure that the contrast range does not exceed the recording capacity of the film. In simple lighting, where the contrast range is less controlled by the photographer, very precise exposure may be necessary, as in Lu Jeffery's shot on page 51.

BATHROOM, PRESIDENTIAL SUITE

▼

BLACK MARBLE; WHITE PORCELAIN; MIRRORS; AND FOUR DIFFERENT TYPES OF LIGHTING — A NIGHTMARE. BETTER STILL, THERE WAS ONLY ONE POSITION FROM WHICH TO TAKE THE PHOTOGRAPH: EVERYWHERE ELSE, THERE WERE REFLECTIONS.

Photographer: **Thomas George Epperson**

Client: **Peninsula Hotel, Manila**

Use: **Editorial and mailer**

Art director: **Ton Ton Santos**

Camera: **4x5 inch**

Lens: **90mm**

Film: **Kodak Ektachrome tungsten-balance**

Exposure: **f/16**

Lighting: **Tungsten**

Props and set: **Location**

The tungsten lights were in fact the modelling lights of three flash heads. One, with snoot and grid, shone through the door to camera left and illuminated the towel. The second, immediately to camera left, had a 180mm (7-inch) reflector and grid. The third, to camera right, lit the marble at the front.

This is the sort of shot where trial and error forces the photographer into a particular shooting position, and lighting then becomes a matter of working at the limits of the range of the film — about a three- or four-stop range, despite a five- or six-stop range of reflectivities.

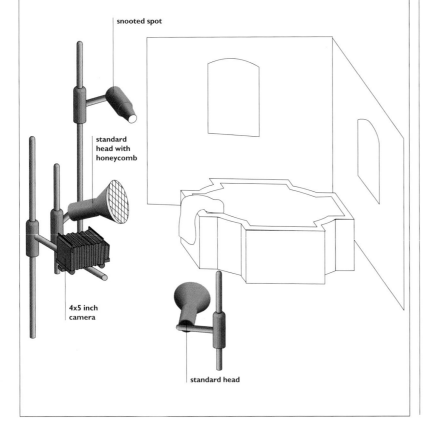

snooted spot

standard head with honeycomb

4x5 inch camera

standard head

► *Brightening dark areas without overexposing light areas requires careful control of spill, which may involve using any or all of the following: snoots, grids, barn doors, flags and scrims*

Photographer's comment:

This shot took three hours — it was one of seven shots of this bathroom. Even then, with more time I would have balanced the other light sources in the room.

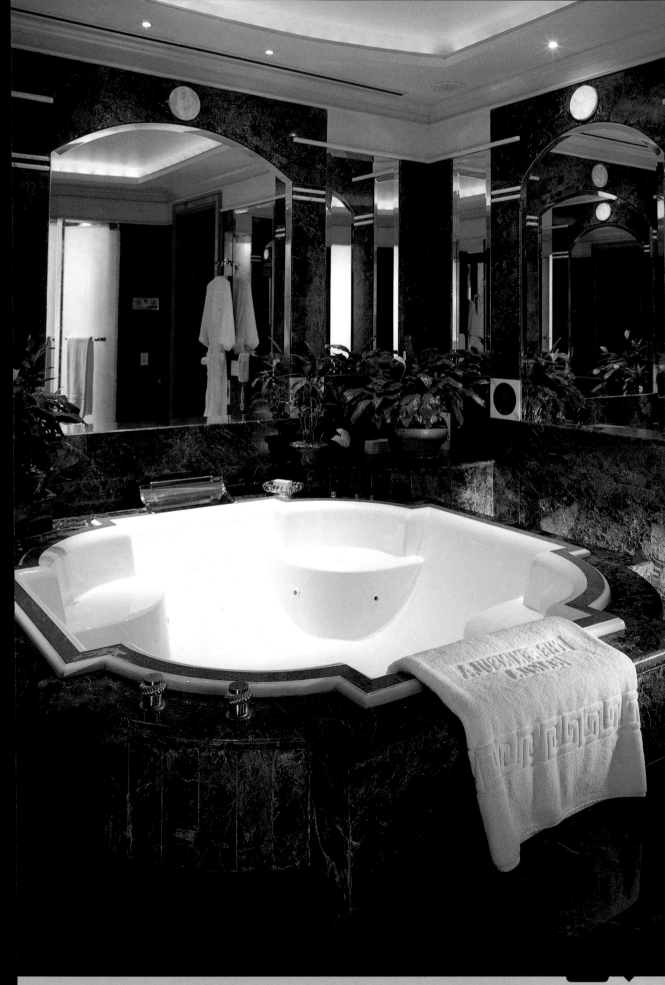

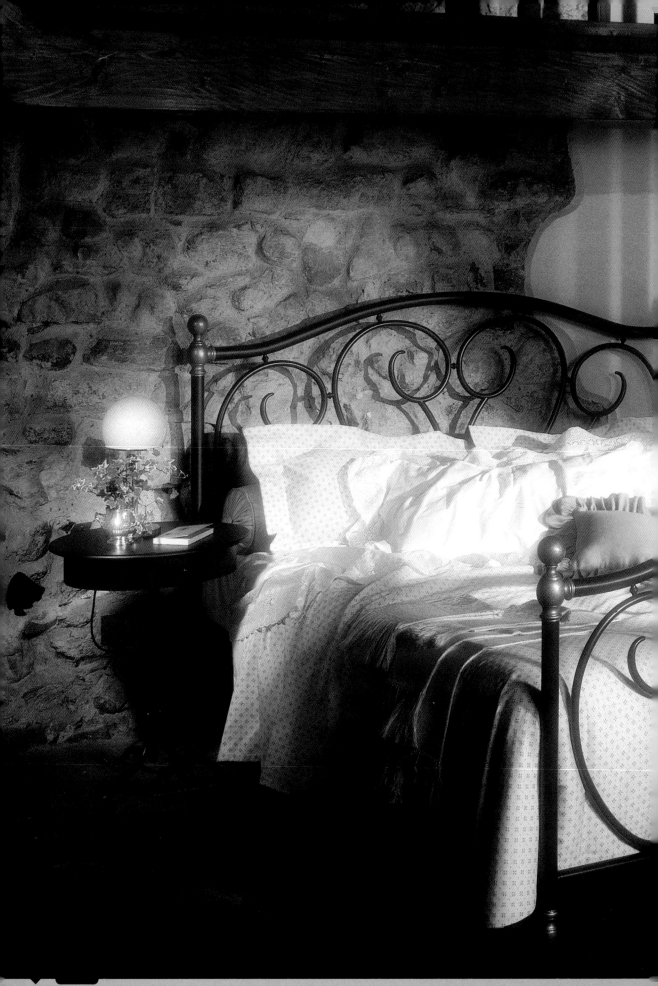

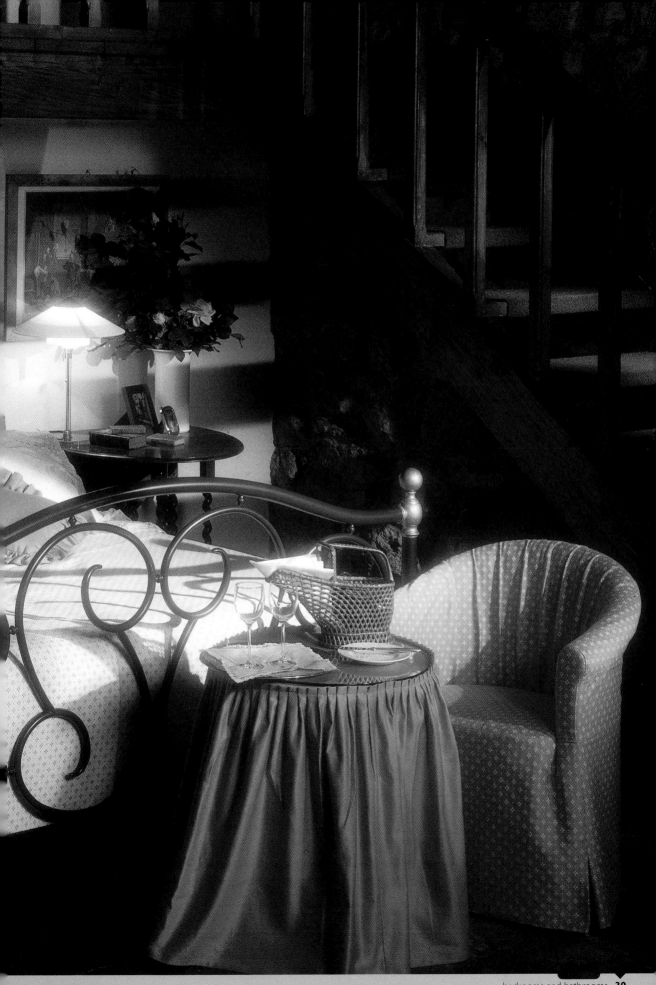

RIVA 3

▼

THE TECHNIQUE OF USING FLASH FOR "DAYLIGHT" AND TUNGSTEN FOR "SUNLIGHT" IS WELL ILLUSTRATED HERE; AT 2800-3000°K, THE COLOUR TEMPERATURE OF SUN NEAR THE HORIZON CAN ACTUALLY BE LOWER THAN THAT OF TUNGSTEN LIGHTING, SO THE EFFECT CAN LOOK VERY NATURAL.

Photographers: **Bruno Vezzoli/Carlo Gessaga, IKB Fotografia**
Client: **Riva**
Use: **Catalogue and press campaign**
Assistant: **Mirko Marton**
Art director: **Natalia Corbetta**
Stylists: **Rossella Battaglia/Laura Comiotto**
Production director: **Enrica Proserpio**
Camera: **4x5 inch**
Lens: **165mm**
Film: **Kodak 6105 Ektachrome Plus 100**
Exposure: **f/22**
Lighting: **Flash and tungsten**

All lighting is to camera right. A powerful flash soft box lights the floor and the wall on the left, while a flash with a standard head and honeycomb lights the bedside table on the right. Then three tungsten heads light the remainder: the bed and the wall behind it, the landing and the stairs. The flash lighting is between half a stop and a stop and a half below the tungsten, which re-creates the effect of sunlight: the "sunlit" parts tend towards overexposure, and the "daylight" parts towards underexposure: cover parts of the picture with your hand to see this even more clearly.

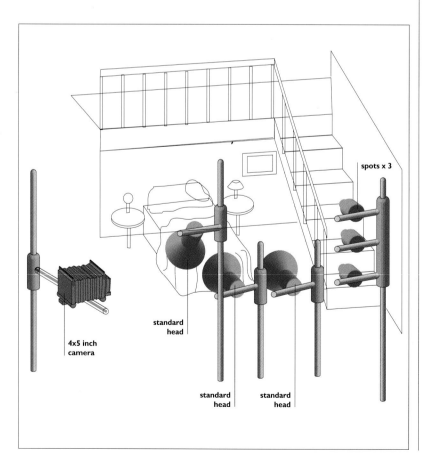

spots x 3

standard head

4x5 inch camera

standard head

standard head

► *If necessary, change the bulbs in domestic lights in shot to give the right exposure*

► *Remember that low-wattage domestic bulbs burn cooler (i.e. more yellow) than high-wattage bulbs*

BEDROOM WITH LILY

▼

THIS IS A CLASSIC EXAMPLE OF HIGH-KEY LIGHTING. WHAT IS MORE, ALL THE LIGHTING IS INDIRECT, USING FOUR STRIPS BOUNCED OFF THE INSIDE OF A WHITE COVE AND FIVE LARGE (120x240CM/4x8 FEET) WHITE FLATS.

Photographer: **Tim Hawkins**

Client: **Texas Homecare**

Use: **Packaging**

Camera: **4x5 inch**

Lens: **150mm with CC05M filter**

Film: **Fuji RDP ISO 100**

Exposure: **f/32**

Lighting: **Electronic flash: 2 heads**

Props and set: **Built set**

The wall behind the bed was built inside a white-painted "cove". A sheet of Kodatrace was used to cover the window. Two strip lights, one on either side of the window, are bounced off the back of the cove and provide the key illumination on the bed. Two more strips, at each end of the wall, are bounced off the walls of the cove at each side, and there are four big expanded polystyrene bounces, two on each side of the camera. These stand vertically, but below the camera there is another 120x240cm (4x8 feet) bounce to provide fill in the lower part of the picture.

Because the picture had to be perfectly white, Tim Hawkins shot a test sheet and had it processed; it was biked to the lab and back for quickest possible processing. In his judgement it was CC05 green, so a CC05M (magenta) filter corrected the colour.

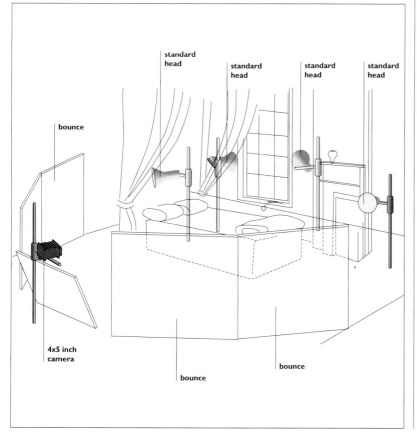

standard head

standard head

standard head

standard head

bounce

4x5 inch camera

bounce

bounce

► The only way to guarantee neutral colour is by the test-process system. Lights can vary; bounces and diffusers can add their own tints; and labs can vary

► Although a correctly balanced transparency is no guarantee of correct balance in final reproduction, and although printers can correct an off-balance transparency, it is always best to show the client the best colour possible

Photographer's comment:

This was shot as the illustration on a can of paint. The lily was not called for in the original brief, so I shot it with and without. The client preferred it without, but I used this version for my portfolio.

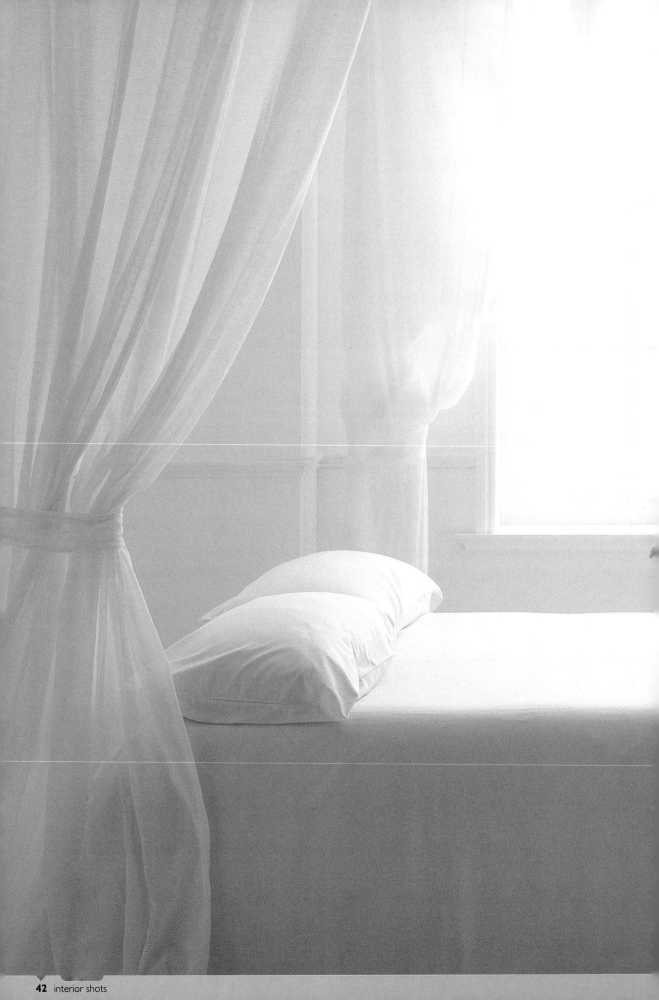

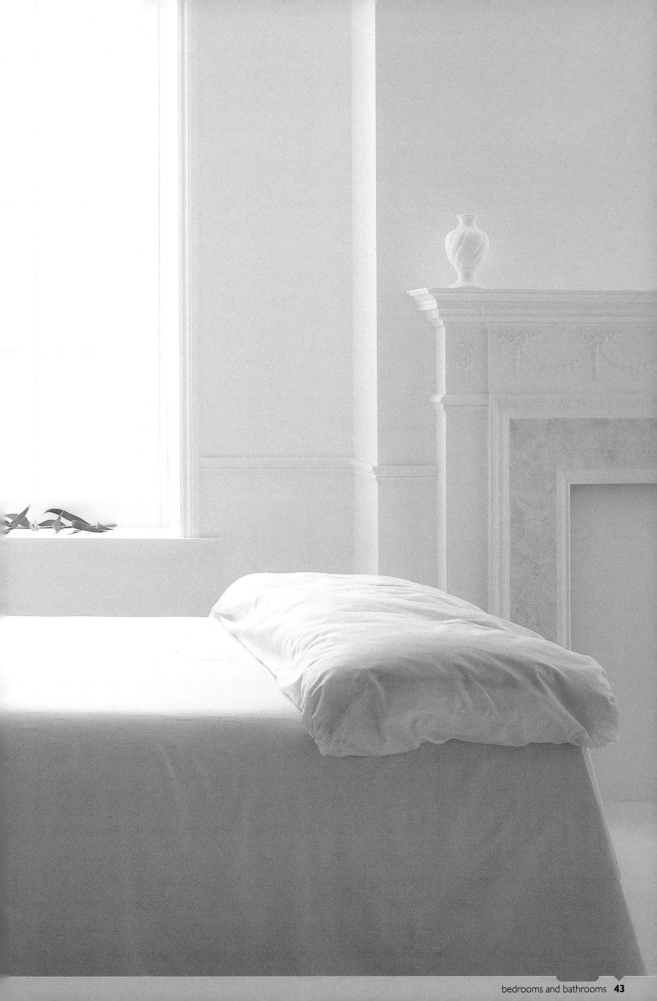

BEDMAKING

▼

THE LIGHTING HERE RE-CREATES THE FRESHNESS OF THE SHEETS AND THE AIRINESS OF A SUNLIT ROOM – BUT THE EFFECTS WERE ACHIEVED WITH ARTIFICIAL LIGHT (AND PLENTY OF IT) AND TWO BIG BOUNCES, ON A GREY, DULL DAY.

Photographer: **Quintin Wright**
Client: **The Draycott**
Use: **Hotel brochure**
Camera: **6x6cm**
Lens: **80mm**
Film: **Kodak T-Max 100**
Exposure: **f/11-1/2**
Lighting: **Electronic flash: 6 heads**
Props and set: **Location**

The key light comes through the window, to be sure, but it is from four heads fed by a 2400 watt-second generator, diffused through tracing paper which covers the entire window: this together with the flat, grey weather outside creates a very large, soft, diffuse light source.

Considerable fill is added by two more heads, one high and one low, in the corner of the room to camera right. These are bounced off a large white sheet, again for a very diffuse effect; they make the rooms seem very large and airy. Yet more fill, though passive this time, comes from another white sheet to camera left, just out of shot. This kicks light back from the window, further softening the shadows on the sheet and on the left side of the drapes above the bed. The choice of black and white film allowed the photographer to create a far greater and more delicate tonal range than would have been possible in colour.

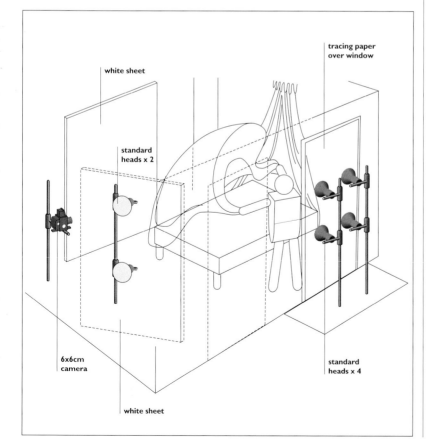

► Only use studio flash out-of-doors in dry weather: the combination of rain or even mist and very high voltages can be fatal

► Although the subject is not particularly high key, the lighting is: very diffuse, and used with slight overexposure

Photographer's comment:

I deliberately chose a very flat, grey day to give me the maximum possible control over the artificial lighting.

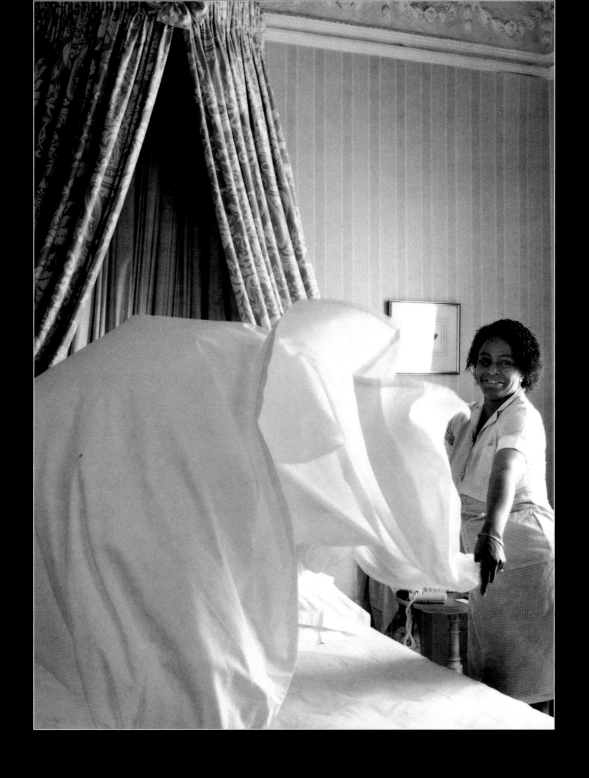

BEDROOM

▼

A NATURAL, SUN-FLOODED CORNER OF A ROOM — EXCEPT THAT IT ISN'T. NO FEWER THAN 8 TUNGSTEN SPOTLIGHTS WERE USED TO CREATE THIS APPARENTLY CASUAL EFFECT: 2× 1000 WATT, 2× 500 WATT, AND 3× 300 WATT. THEN THERE WAS THE LIGHT IN THE PICTURE!

Three 300W lights shone through a paper grid to cast the shadows on the wall and to create the streak of "sunlight" on the chest of drawers. One 1000W light provided slight back lighting to the blue fabric on the bed, while the other was lower and shone into the set to light the bed and the pillow. One 500W spot provided fill from the left of the camera, while the other two shone straight down, creating the brilliant patches of colour on the blue under-pillow.

Photographers: **Arici and Mauroner**
Client: **Gruppo Due**
Use: **Magazine**
Assistants: **Beppe Di Tonno, Cristina Canesella**
Art director: **Mario di Carand**
Camera: **8x10 inch**
Lens: **210mm**
Film: **Kodak Ektachrome tungsten-balance**
Exposure: **Not recorded**
Lighting: **Tungsten: 8 spotlights**
Props and set: **Various sources**

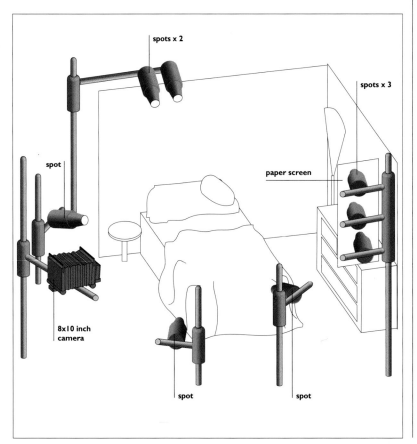

spots x 2

spots x 3

spot

paper screen

8x10 inch
camera

spot

spot

► *Multiple spotlights afford tremendous creative potential, at the serious risk of crossed shadows*

► *Narrow-angle spots, possibly combined with barn doors, snoots and flags, allow the photographer to put the light exactly where it is needed while avoiding spill*

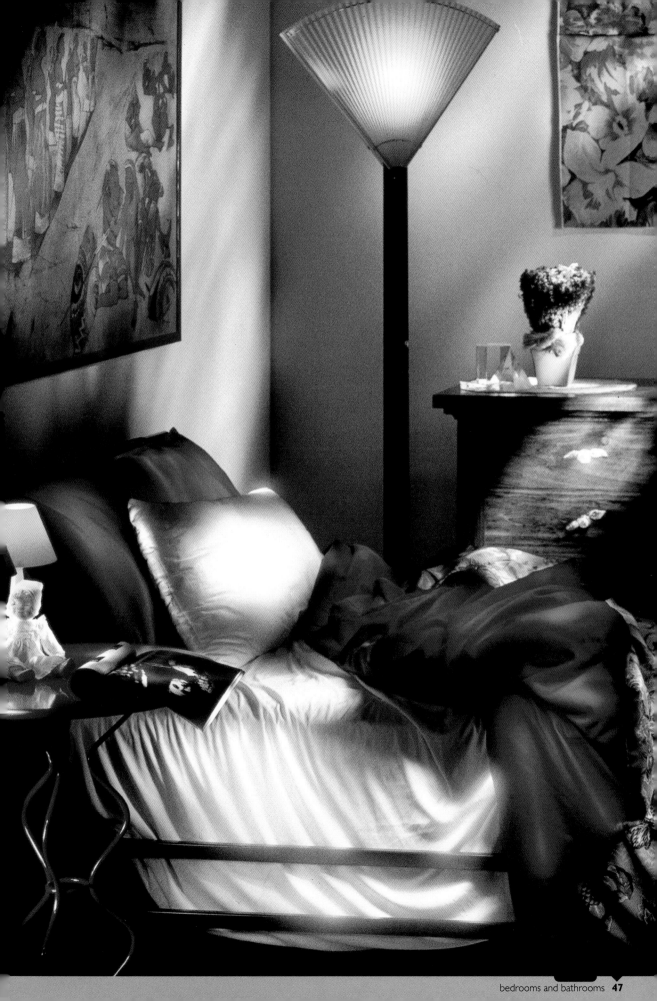

BEDROOM DETAIL

▼

Photographer: **Neil Hudson**

Client: **Storeys Fabrics**

Use: **Brochure/magazine**

Art director: **Brian Franklin**

Set building, styling, paint: **Roland Myers**

Camera: **4x5 inch**

Lens: **210mm with soft screen for one exposure**

Film: **Kodak Ektachrome EPP**

Exposure: **f/22-1/2, double exposure**

Lighting: **Electronic flash: 3 heads**

Props and set: **Built set**

As REMARKED ELSEWHERE IN THIS BOOK, CATEGORIES IN PHOTOGRAPHY ARE SELDOM WELL-DEFINED. HERE, STILL LIFE MEETS THE PHOTOGRAPHY OF INTERIORS: IT IS A FABRIC ADVERTISEMENT, BUT IT IS ALSO A CORNER OF A BEDROOM.

The "sunlight" comes from the key, a spot shone through a gobo to camera left. This glances along the wall and the edges of the fabric, creating strong chiaroscuro on the window drapes. The first exposure, with the soft screen in place, uses only this light together with the background light on the far side of the window.

The second exposure, without the soft screen, uses three lights. One is a spotlight for the table and the chair: look at the highlights on the chair. Another spotlight, outside the window, rim lights the props on the window ledge. Fill is provided by a standard head bounced into a V-shaped reflector on the extreme right. Without this, the near side of the chair in particular would be very dark.

Split or double exposures, with and without a soft screen, are more usually associated with product shots and special effects than with indoor photography, but as Neil Hudson shows, this can be a very effective technique in this branch of photography.

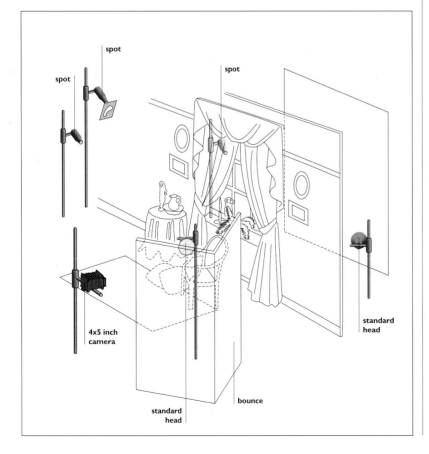

► *One way to emphasize depth is through perspective, by using a close viewpoint and a wide-angle lens. This is seen elsewhere in the book. Another, as seen here, is through strong chiaroscuro*

► *Techniques learned in one type of photography can often be applied in another*

Photographer's comment:

Careful use of lighting has helped to portray a feeling of depth in this simple room set.

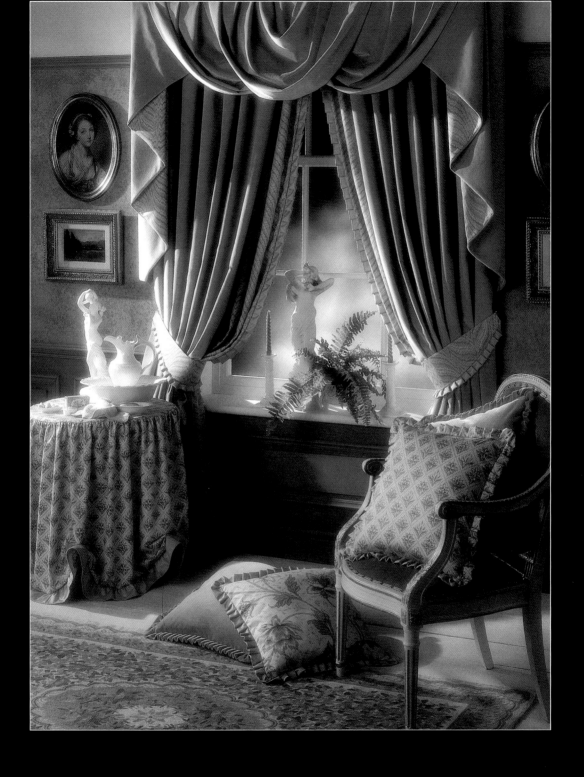

CLASSICAL BATHROOM

▼

BEFORE THE TWENTIETH CENTURY, NATURAL LIGHT WAS USED FAR MORE THAN IT IS TODAY AND IN OLDER HOUSES IT IS SOMETIMES POSSIBLE TO WORK WITHOUT SUPPLEMENTARY LIGHTING. IN THIS CASE, NATURAL LIGHT IS PARTICULARLY APPROPRIATE TO THE MORNING *TOILETTE*.

The light is quite contrasty, which suits both the strong graphic shapes and (again) the morning nature of the room, though a silver reflector in the doorway to the left gave a little more definition to the left hand side of the hand basin and to the towel hanging below it.

In order to take the picture – which was shot hand-held – the photographer was actually in the bath tub, with her back to the wall, taking the photograph from as far back as possible.

Photographer: **Lu Jeffery**, Client: *Period Living*, Use: **Editorial**, Camera: **6x6cm**, Lens: **40mm** Film: **Fuji RDP ISO 100** , Exposure: **1/125 second at f/8**, Lighting: **Ambient daylight plus silver reflector**, Props and set: **Cracked Roman pot**

Photographer's comment:

Always take your shoes off before you get into the bath . . .

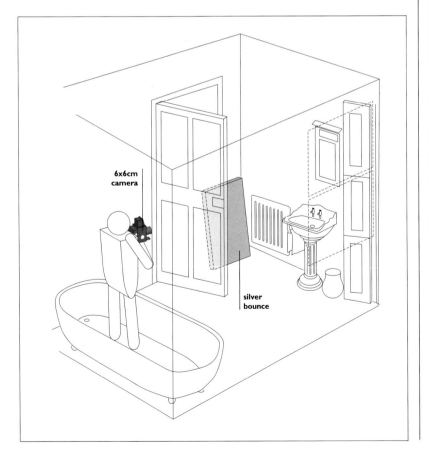

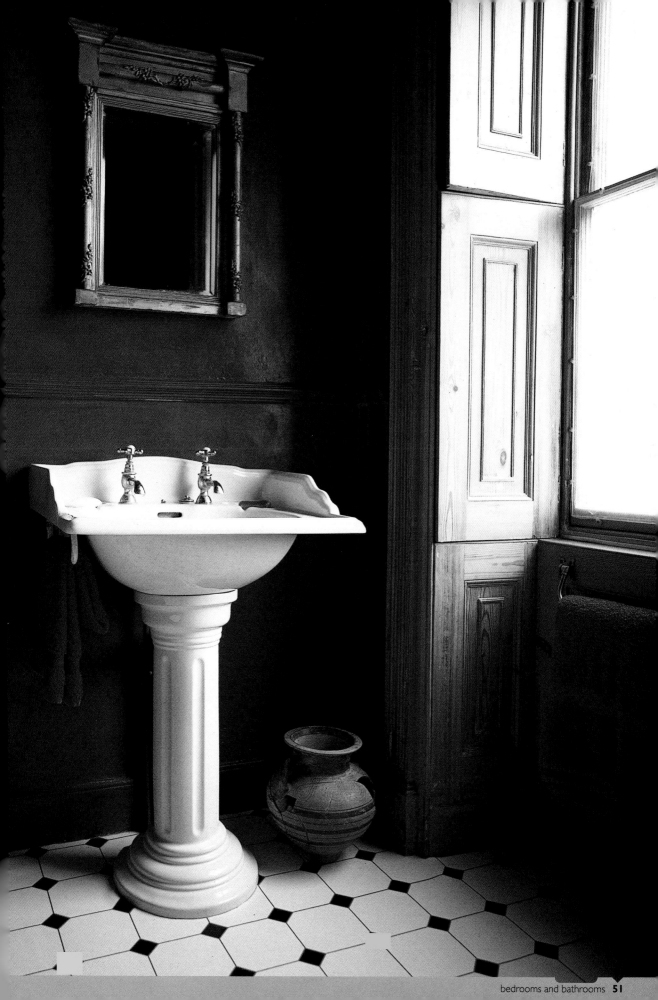

BATHROOM

▼

Photographer: **Neil Hudson**

Client: **Vernon Tutbury**

Use: **Magazine/brochure**

Styling and paint: **Roland Myers**

Camera: **4x5 inch**

Lens: **135mm with soft-focus screen for one exposure**

Film: **Kodak Ektachrome EPP**

Exposure: **f/32, double exposure**

Lighting: **Electronic flash: 4 heads**

Props and set: **Built set**

THE LIGHT THROUGH THE FAR WINDOW — BRIGHT, YET DIFFUSED AND SOFT — IS AN EXCELLENT EXAMPLE OF HOW PHOTOGRAPHIC MANIPULATION MAY AND INDEED SOMETIMES MUST BE USED TO RE-CREATE THE WAY THAT WE THINK WE SEE THINGS, RATHER THAN A STRAIGHT RECORD.

A very large soft box covering the whole of the far window was the only light used for the first exposure, with a soft focus screen over the lens. This was switched off for the second exposure, which was lit by three quite different lights. The key is a spot through the window to the right, but this is supplemented with a focusing spot (with gobo) to light the area by the hand basin (look at the light streaks on the wall and at the highlights)

and with a fill to camera right which is achieved with a standard head bounced into a broad "V" bounce.

Although such a technique could in theory be used on location, it would be difficult to mask off one window, and it might also be risky in view of the springiness of many floors, especially in old houses; there would be a severe risk of the camera moving, even if fractionally, between exposures.

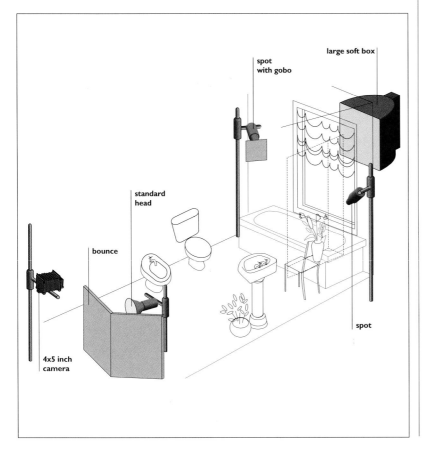

large soft box

spot
with gobo

standard
head

bounce

4x5 inch
camera

spot

► A soft-focus screen can provide usefully natural-seeming flare around a window

► Multiple exposures require firmer floors than are often found on location

► The larger the format, the less problem there is likely to be with failures of registration

Photographer's comment:

By lighting through the windows and balancing the lighting, a natural effect has been achieved with just a little help from an additional light.

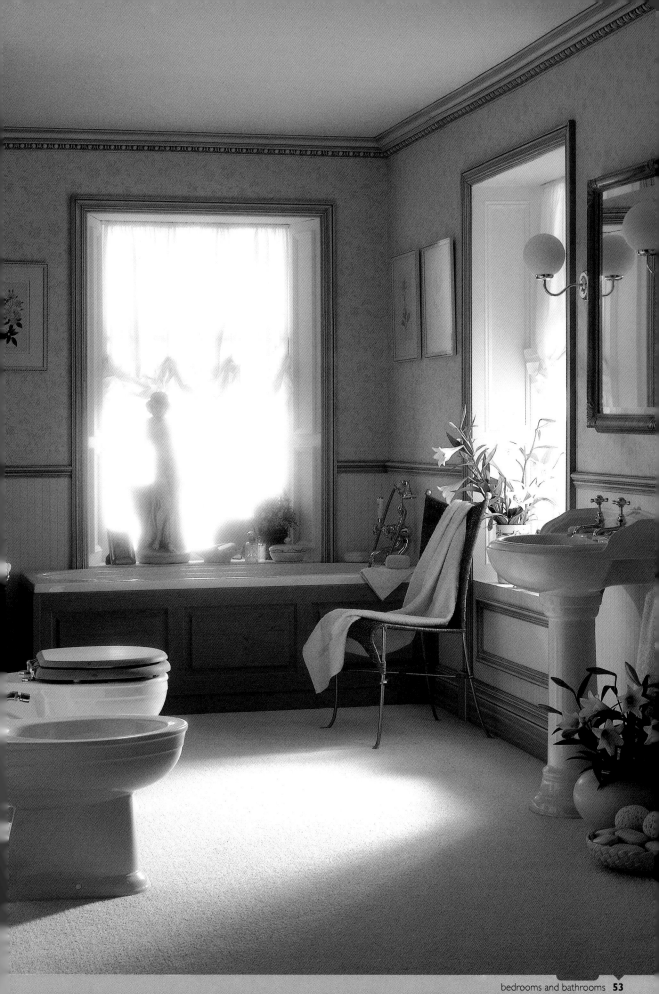

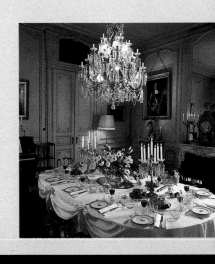

3 kitchens and dining rooms

▶ With dining rooms, and increasingly with kitchens, we are back within the realms of "public rooms". Kitchens were once the domain of servants, and it can be instructive for someone who is used only to modern European kitchens for the middle classes to see traditional kitchens in countries where servants are still the norm: the sense of design which characterizes the public room is very likely to be missing. Today, even the well-to-do are quite likely to treat the kitchen as a living and dining room, much as the poor would have done in the past: many older houses for working people are built around the kitchen, which would normally have been the warmest room in the house.

This blurring of the distinction between kitchens and dining rooms is why the two are treated together here, though they do have their own characteristics. The dining room is normally more tranquil, more formal, while the kitchen reflects its role as a place of work as well as a place of relaxation. The kitchen is also more subject to the whims of fashion: the "country" look is perennially fashionable, but "high-tech" kitchens come and go and at the time of writing there was a certain nostalgia for the period between the wars, especially the 1920s.

The technical problems of photographing the two are surprisingly analogous to the technical problems of photographing bedrooms (analogous with dining rooms) and kitchens (analogous with photographing bathrooms), namely the tension between mere function and pure design.

KITCHEN

▼

Photographer: **Tim Hawkins**
Client: *Southside* **Magazine**
Use: **Editorial**
Camera: **4x5 inch**
Lens: **90mm**
Film: **Fuji RDP**
Exposure: **I second at f/32**
Lighting: **Electronic flash: 3 heads, plus daylight**
Props and set: **Location**

AT FIRST SIGHT, THIS LOOKS TOTALLY NATURAL AND UNLIT – WHICH IS (OR SHOULD BE) THE CRITERION FOR ALL ARCHITECTURAL INTERIORS. IN PRACTICE, THREE FLASH HEADS WERE USED, ONE OF THEM OUTSIDE THE WINDOW ON THE WALL TO THE LEFT.

The key lights must appear to be those which are in shot, namely the window; the light over the door; and the light over the hob, inside the chimney breast. If these were the only lights, though, the room would appear to be very dark with pools of overexposure and there would be very poor differentiation between the table in the foreground and the hob and worktops behind it. The window, as already noted, was supplemented with a large soft box outside the house, but this was principally because it would have looked strangely dark otherwise. The key lights are effectively another soft box, just out of shot in the upper right-hand corner, and a standard head almost directly over the camera which illuminates the table in the foreground. The shutter was then "dragged" at one second to give adequate weight to the tungsten light source.

soft box outside window

soft box

4x5 inch camera

standard head

► It is often necessary to "pump up" or accentuate a light source in shot in order to allow it to compete with additional lighting out of shot

► Kitchens are famous for their chiaroscuro, but equally, colour films can only record colours across a limited range of tones

Photographer's comment:

The main problem in many architectural shots lies in differentiating near, middle and far.

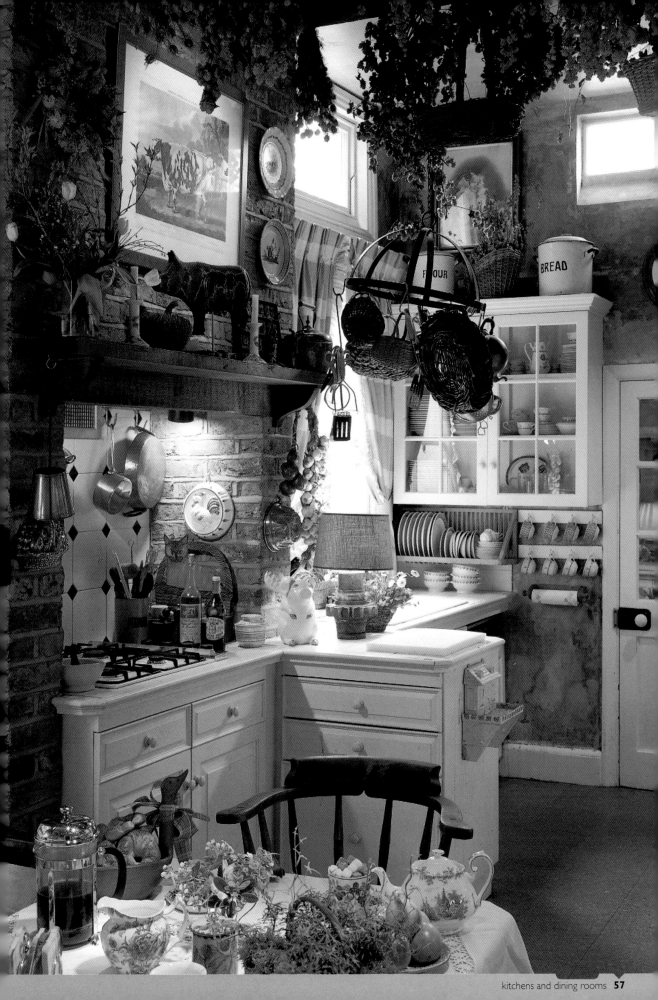

LIBECO BROCHURE

▼

Photographer: **Michèle Francken**

Client: **Libeco/Belgian Linen**

Use: **Brochure**

Stylist: **Christ'l Exelmans**

Camera: **6x8cm**

Lens: **210mm**

Film: **Kodak Ektachrome EPP ISO 100**

Exposure: **1/15 second at f/16**

Lighting: **Daylight plus flash**

Props and set: **Location shot**

THE PHOTOGRAPHER SUMMED UP THE LIGHTING PERFECTLY IN HER OWN WORDS: "LA SUBTILITÉ DE LA LUMIÄRE A ÉTÉ OBTENUE GRÂCE À UN FEU DE MIROIRS" — THE SUBTLETY OF THE LIGHTING WAS OBTAINED BY USING A BLAZE OF MIRRORS.

The wall behind the camera was generously pierced with windows, and under each window Ms. Francken placed a mirror to reflect light where it was needed: to the far wall, to the table and so forth. Although multiple light sources are generally regarded as bad news, and although beginners are advised never to use mirrors as reflectors, the "rules" no longer apply in the hands of a highly skilled photographer. The mirrors help to even out the illumination; some of them were covered with a light transparent material to soften the light further. Finally, overall contrast was softened by means of a powerful flash reflected from the white-painted ceiling.

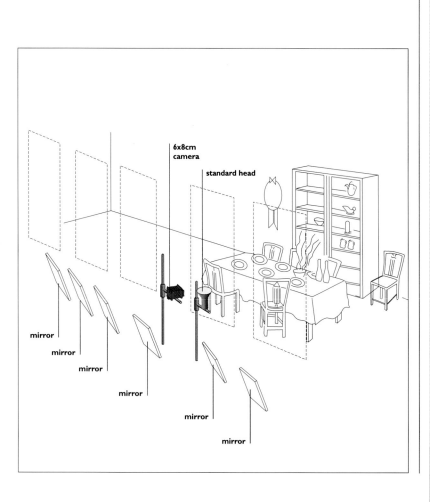

▶ *Mirrors do not have to be glass: plastic mirrors, or even mirror foil on foam-core board, may suffice*

▶ *The amount of power required for the fill flash will depend on the height of the ceiling*

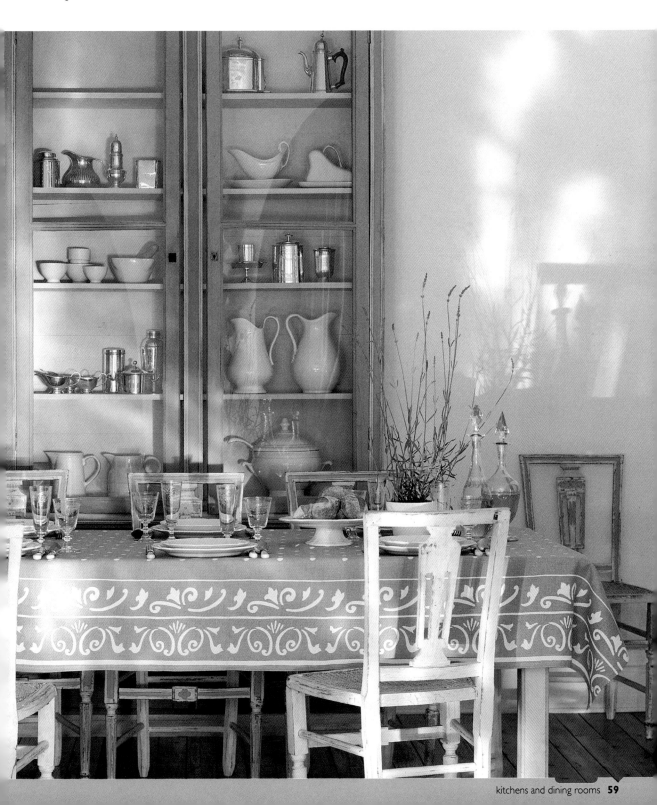

DINING ROOM

▼

TOO LITTLE EXPOSURE, AND THE LIGHTS IN SHOT WILL LOOK DULL; TOO MUCH, AND THEY BURN OUT. THE BEST IDEA IS TO SET THE EXPOSURE TO SUIT THE CHANDELIER AND THE CANDLES, AND THEN TO ADJUST THE REST OF THE LIGHTING TO SUIT THIS.

There is no true key in a shot like this. The lights in shot must appear believable, but if they were the only light source the effect would be one of pools of light in a sea of darkness. As it is, the nearest to a key light is the soft box to camera left; the soft box to camera right acts as a fill.

The third flash head, to camera left, adds some light to the overall scene in the form of bounce light from the ceiling; but its main purpose is to illuminate the ceiling as reflected in the mirror.

A very small aperture was necessary for depth of field – and the long exposure was determined to suit this.

Photographers: **Michel de Meyer and Max Schneider,** Client: **Proeven,** Use: **Editorial**
Assistants: **Filip Thirion and Christine Struyf,** Art director: **Leonce Bihet**
Camera: **6x6cm,** Lens: **80mm,** Film: **Kodak Ektachrome Plus ISO 100 (EPP)**
Exposure: **f/16; long exposure, not recorded,** Lighting: **Available light plus flash: 3 heads**
Props and set: **Location: castle interior and rented table props**

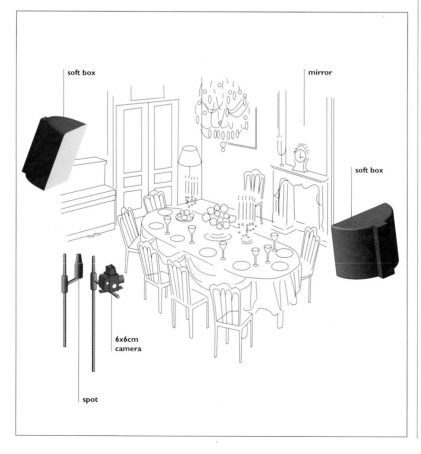

soft box

mirror

soft box

6x6cm camera

spot

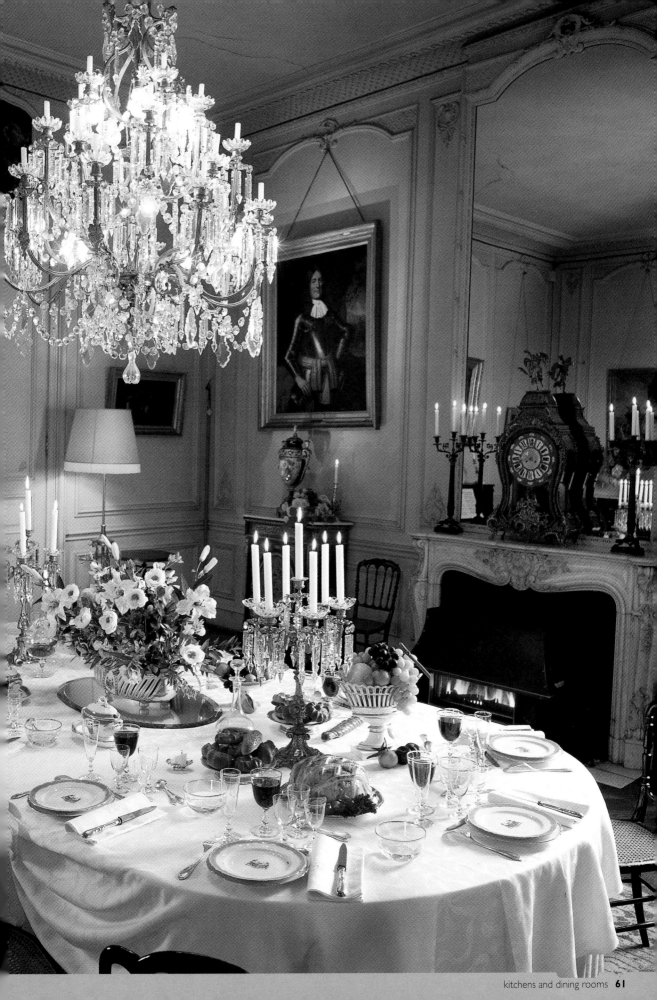

KITCHEN/
CONSERVATORY

▼

IN THIS CORRIDOR-LIKE KITCHEN, OPENING ONTO A CONSERVATORY THERE WAS VERY LITTLE CHOICE OF CAMERA POSITION; THE AIM HAD TO BE TO SHOW THE ECONOMICAL AND THOUGHTFUL USE OF SPACE AND THE GENEROUS NATURAL LIGHT.

Photographer: **Quintin Wright**

Client: **Frost & Co.**

Use: **PR – Editorial**

Camera: **4x5 inch**

Lens: **90mm**

Film: **Fuji RDP ISO 100**

Exposure: **1/30 at f/22-1/2**

Lighting: **Electronic flash: 1 head and tungsten: 2 heads**

Props and set: **Vegetables on counter bought specially**

The classic manoeuvre of bouncing a light off the ceiling to camera left was the obvious beginning – but a great deal of power was needed because of the small aperture necessary for depth of field and the bright light streaming in through the windows. A 2400w-s head with a standard reflector, mounted on a stand well over two metres high (approximately 7'6''), took care of this. With just this lighting, though, the work surface on either side of the sink was a big black hole – altogether unacceptably dark. Covering the surfaces with vegetables specially bought for the shot alleviated this considerably, but there was then a need for more light on the vegetables themselves. Two 150 watt tungsten "peppers" (miniature spotlights) solved this problem; they were mounted on a boom over the camera and kicked in just enough light to do the job.

spots x 2

standard head

4x5 inch camera

► Relatively low-wattage tungsten lights like the "peppers" can lighten and warm dark areas without appearing too obvious if they are 2 stops or more weaker than the overall light

► Mounting lights on booms over the camera can be surprisingly versatile

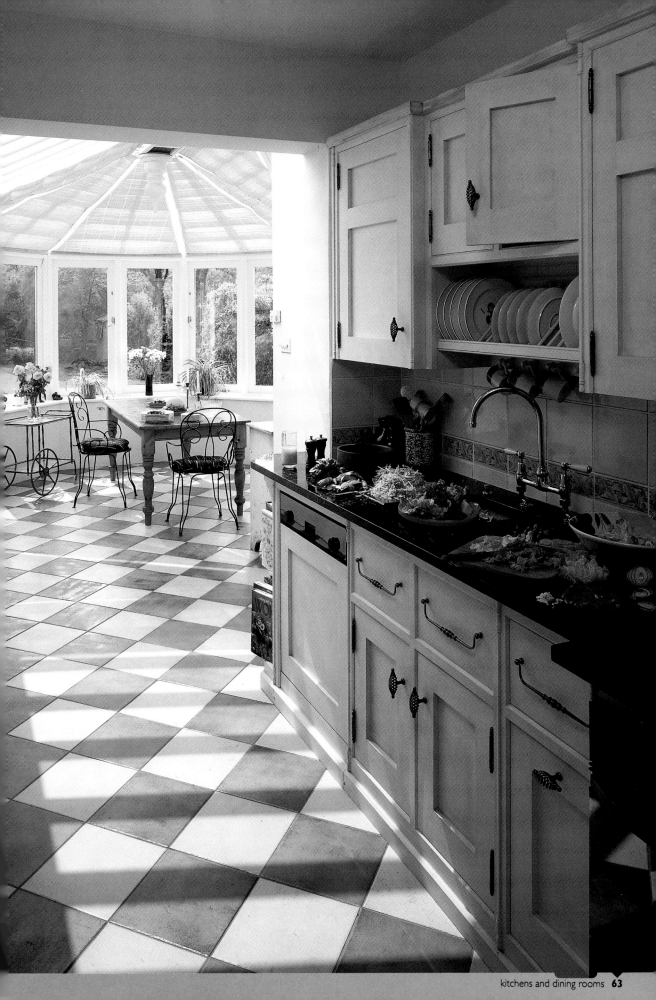

JENNIFER ALDRIDGE IN HER KITCHEN

▼

Photographer: **Lu Jeffery**
Client: *Ideal Home*
Use: **Editorial**
Model: **Angela Piper**
Assistant: **Richard Thoday**
Camera: **6x6cm**
Lens: **150mm**
Film: **Fuji Provia RDP2 ISO 100**
Exposure: **1/2 second at f/16**
Lighting: **Electronic flash: 3 heads**
Props and set: **Food; cover of cook book; ornaments**

"JENNIFER ALDRIDGE" (PLAYED BY ANGELA PIPER) IS A PRINCIPAL CHARACTER IN BRITAIN'S LONGEST RUNNING WIRELESS SOAP OPERA, "THE ARCHERS". THIS WAS ONE OF A SET OF 11 PICTURES SHOT IN A SINGLE DAY TO ILLUSTRATE "JENNIFER'S HOUSE."

The book propped on the table is Jennifer Aldridge's *Archers' Cookbook*, an essential part of the shot, which was not there when the photographer arrived and which was not delivered until a nerve-wracking two hours later. For obvious reasons, the food and the ornaments were extremely carefully chosen and styled to the hilt; the trug of vegetables against which the book leans is a still life in its own right.

The key lighting comes from camera right: a bounce umbrella well to camera right and well above eye level supplemented by a soft box beside the camera (look at the highlights in the eyes). To camera left, another small soft box was set some two stops down as a fill. The light in the upper corner of the room adds warmth and neatly counterbalances the tones of the trug of vegetables on the lower left.

soft box

standard head with umbrella

soft box

6x6cm camera

► *Some people – especially professional actresses like Angela Piper – can hold half-second and even one-second poses*

► *It was important to get just the right clothes and pinafore for the "country kitchen" look*

► *Note how everything is in character – even down to the de rigeur Dualit toaster*

BABINGTON HOUSE KITCHEN

▼

As so often, it is the details which lift this shot from the good to the excellent. The jam on the table; the fresh-cut cake; the open door on the superb centuries-old cupboard on the far wall – and all are complemented by sensitive lighting.

A bounce umbrella mounted very high to camera left lights the ceiling and the clothes-drying rack; it is effectively the key, as witness the shadows and highlights on the table, the chairs and the cupboard on the wall. A second bounce umbrella to camera right, mounted a little above eye level, adds fill and illuminates the items hanging on the wall to the left of the Aga.

A third light, a bare-bulb head, is mounted low behind the wall to the left of the Aga to fill what would otherwise be a rather dark area, and a small reflector below the window to the right (look at the extreme right-hand reflection in the kettle) kicks more light into the dark green of the Aga.

Photographer: **Lu Jeffery,** Client: *Period Living*, Use: **Editorial,** Assistant: **Richard Thoday**
Camera: **6x6cm,** Lens: **50mm,** Film: **Fuji Provia RDP2 ISO 100 ,** Exposure: **1/2 second at f/16**
Lighting: **Electronic flash: 3 heads and windowlight ,** Props and set: **Gathered from around the house and kitchen**

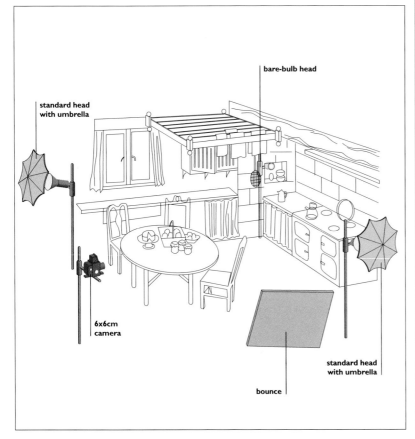

standard head with umbrella

bare-bulb head

6x6cm camera

standard head with umbrella

bounce

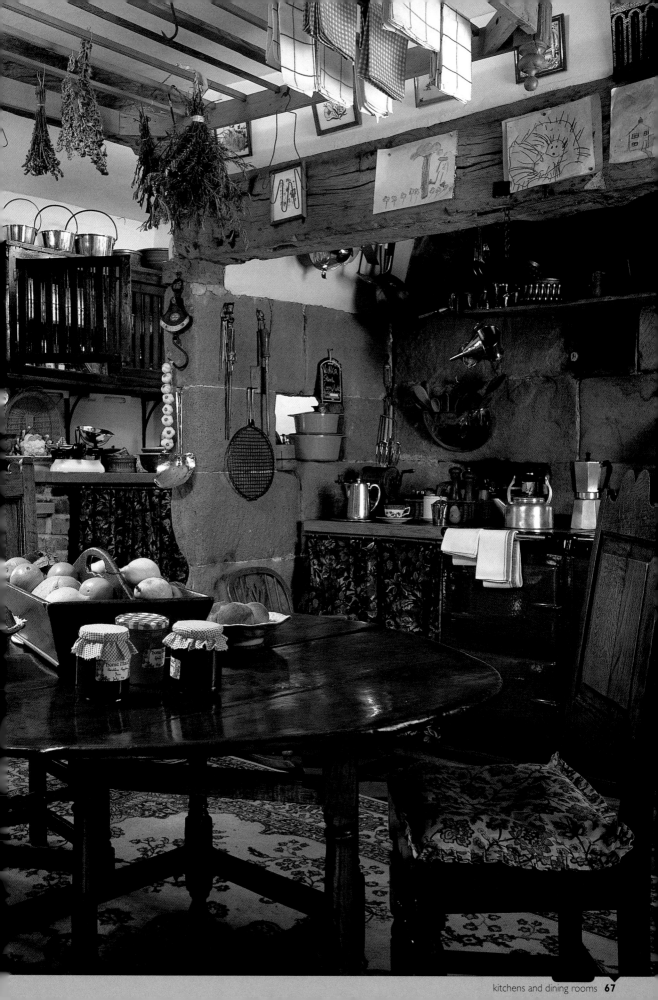

CHIAROSCURO HOLE IN WALL

▼

THE LIGHTING HERE IS AS ELEGANT AS THE STYLE OF THE BUILDING ITSELF. THE ONLY SUPPLEMENTARY LIGHTING IS A BOUNCE UMBRELLA TO CAMERA LEFT, BUT THE POSITIONING OF THIS IS CRITICAL; IT WOULD HAVE BEEN ALL TOO EASY TO LOSE THAT BEAUTIFUL CURVE IN THE WALL.

The hall is lit only by the light through the door; note how a shutter across the door softens and reduces the light. The kitchen is again lit only by natural light through the window which is just visible above the sink; the blueness of the light in the kitchen well illustrates the difference between daylight and sky light. As ever, the table had to be garnished with props gathered from around the house, and the serving hatch also had to be ornamented to stop it looking too bare: the Starck orange squeezer, the three glasses, the white pot and the flowers all temper the geometric formalism of the architecture. Reflections in the table also meant that supplementary lighting had to be placed carefully.

Photographer: **Lu Jeffery**

Client: *Homes & Gardens*

Use: **Editorial**

Stylist: **Kate Hardy**

Camera: **6x6cm**

Lens: **150mm**

Film: **Fuji RDP ISO 100**

Exposure: **1 second at f/1**

Lighting: **bounce umbrella left**

Props and set: **flowers, fruit**

standard head with umbrella

6x6cm camera

► *Clean, simple architectural styles like this are often best served by clean, simple lighting; note that the overhead lights are not switched on*

► *The best props are generally those gathered in the house itself, as they reflect the owner's tastes (which presumably matches the design of the house)*

Photographer's comment:

I originally shot this at 1/8 second at f/8, with the owner of the house in shot, but there wasn't enough depth of field. This re-shot version was used with the person dropped in electronically – the first time this has ever been done with one of my pictures.

4 clubs, pubs, hotels and shops

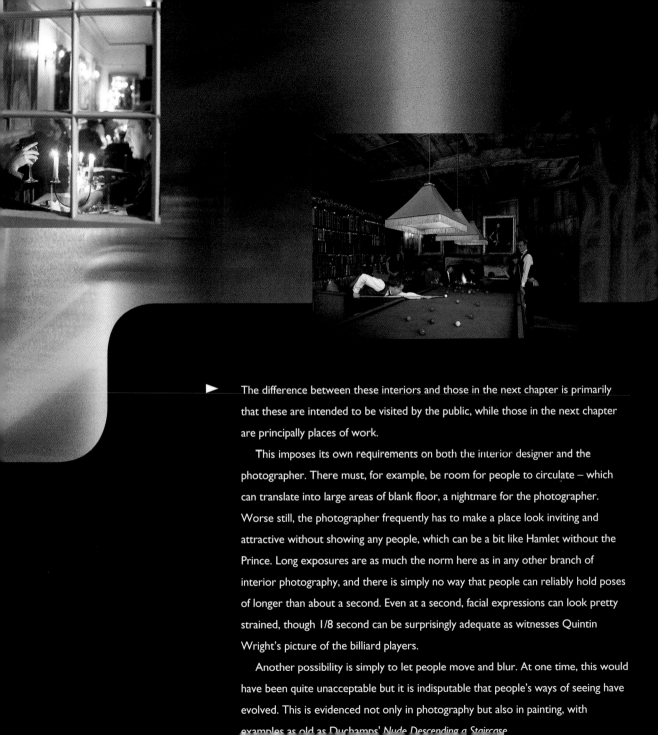

The difference between these interiors and those in the next chapter is primarily that these are intended to be visited by the public, while those in the next chapter are principally places of work.

This imposes its own requirements on both the interior designer and the photographer. There must, for example, be room for people to circulate – which can translate into large areas of blank floor, a nightmare for the photographer. Worse still, the photographer frequently has to make a place look inviting and attractive without showing any people, which can be a bit like Hamlet without the Prince. Long exposures are as much the norm here as in any other branch of interior photography, and there is simply no way that people can reliably hold poses of longer than about a second. Even at a second, facial expressions can look pretty strained, though 1/8 second can be surprisingly adequate as witnesses Quintin Wright's picture of the billiard players.

Another possibility is simply to let people move and blur. At one time, this would have been quite unacceptable but it is indisputable that people's ways of seeing have evolved. This is evidenced not only in photography but also in painting, with examples as old as Duchamps' *Nude Descending a Staircase*.

BILLIARD ROOM

▼

THIS IS AN INTERIOR TO MAKE THE BLOOD RUN COLD: IMMENSE AND DARK,
DEEP FROM FRONT TO BACK AND THEREFORE REQUIRING SMALL APERTURES FOR DEPTH
OF FIELD, AND FEATURING LIVE MODELS WHICH MEANS THAT EXPOSURE TIME HAS TO
BE SHORT ENOUGH TO FREEZE MOVEMENT.

In the event, this translated into more than 9000w-s of flash plus two 800 watt tungsten "Redheads". The most powerful single light was a soft box to camera left with twin 2400w-s packs fed into it, a total of 4800w-s. To camera right, another soft box was lit with a third 2400w-s. A third head with 650w-s illuminated the dark area behind the right-hand player. The fourth head was a bare-bulb 1200w-s unit hidden behind the billiard table itself to illuminate the area near the fireplace. The "Redheads" were used to light the two paintings on either side of the fireplace, with a warm, tungsten glow which echoed the lights over the table.

Photographer: **Quintin Wright,** Client: **Ripley Castle,** Use: **PR/Marketing,** Camera: **4x5 inch**
Lens: **121mm,** Film: **Fuji RDP ISO 100,** Exposure: **1/8 second at f/32,** Lighting: **Electronic flash:**
4 heads plus 2 tungsten spots, Props and set: **Location**

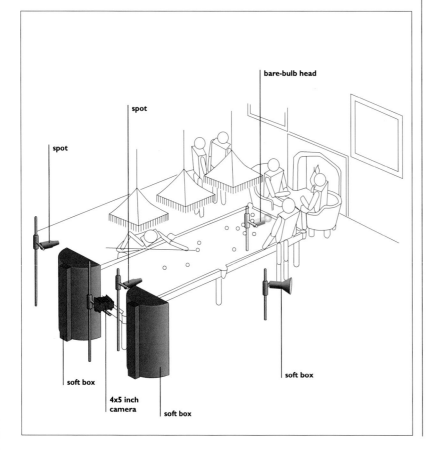

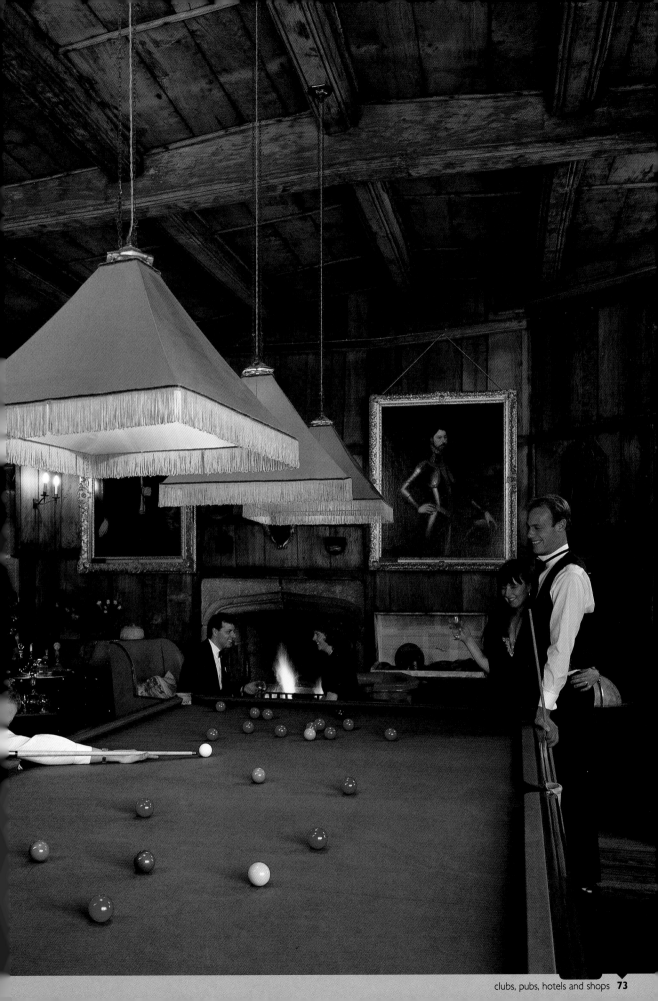

C H E Q U E R S

▼

THERE ARE NO FEWER THAN SEVEN SUPPLEMENTARY LIGHTS IN THIS PICTURE:
FOUR SOFT BOXES AND THREE STANDARD HEADS WITH HONEYCOMBS. THESE HAD TO BE
VERY CAREFULLY BALANCED TO THE TUNGSTEN LIGHT TO RETAIN THE OVERALL COLOUR
WHILE "POPPING" THE BRIGHT BLUES.

Photographer: **Roy Genggam**

Client: **Laros**

Use: **Magazine**

Assistants: **Santo and Kamto**

Camera: **6x7cm**

Lens: **50mm**

Film: **Fuji RDP ISO 100**

Exposure: **8 seconds @ f/16**

Lighting: **Flash and available tungsten light**

Props and set: **Location**

Two soft boxes to camera left provide the light on the area behind the bar with its impressive array of bottles as well as lighting the rear table to centre left. The honeycomb head to camera left lights the picture on the wall to camera right. Another soft box is hidden in the entrance to the bar (on the right hand end), along with a honeycomb spot. As well as brightening the bar, these lighten what would otherwise be a dark,
unwelcoming hole in the centre of the composition. The fourth soft box, again supplemented by a honeycomb standard head, illuminates the vividly-coloured table in the foreground.

Contrasting tungsten light and flash in this way creates the impression of very saturated colours. Where there is no flash, all colours go yellow; where there is flash, true colours are accentuated by comparison.

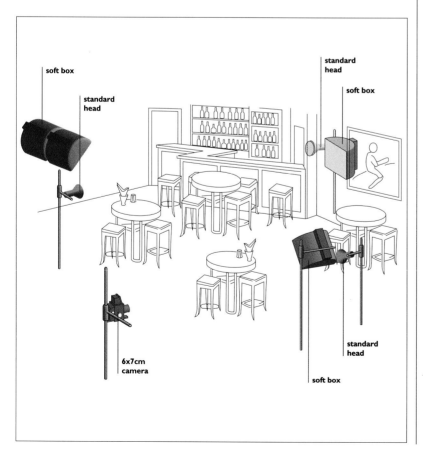

soft box

standard
head

standard
head

soft box

6x7cm
camera

standard
head

soft box

► Yellow walls of some hues record much the same colour by both tungsten light and flash – look at the doorway to the bar

► Different films respond to yellows and blues and to different light sources in different ways; this picture might have looked quite different on another film stock

Photographer's comment:

We wanted the blue colour still to come out while retaining the tungsten effect of the light.

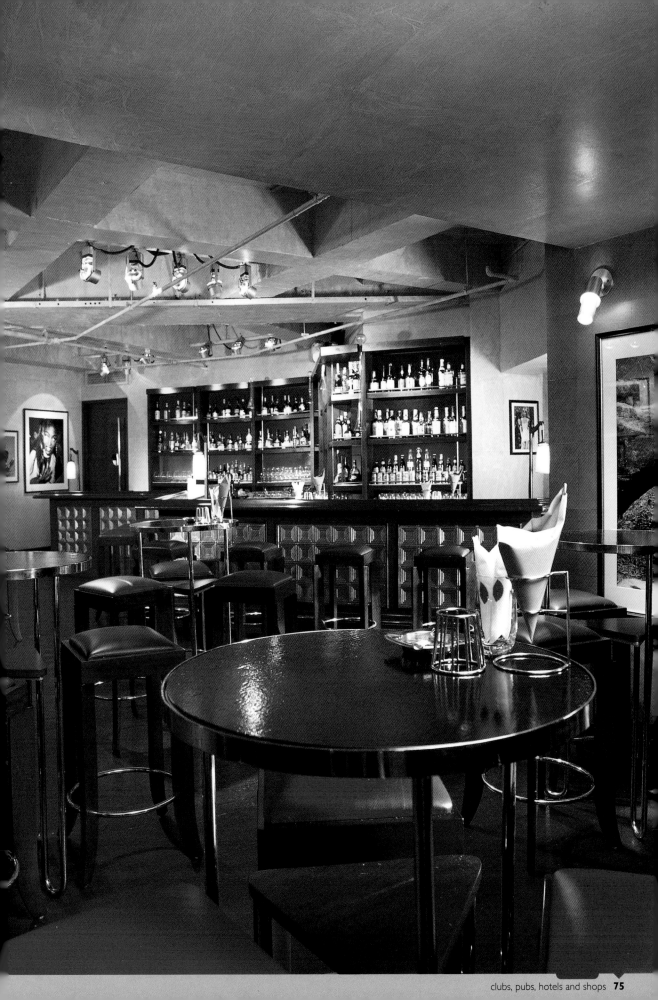

MANDARIN HOTEL, JAKARTA

▼

THE MAIN PROBLEMS WITH A SHOT LIKE THIS ARE FIRST, GETTING ENOUGH LIGHT TO ILLUMINATE SUCH A LARGE INTERIOR AND SECOND, POSITIONING THE LIGHTS, WHICH MAY HAVE TO BE A CONSIDERABLE DISTANCE FROM THE GROUND.

Photographer: **Edwin Rahardjo**
Client: **Mandarin Hotel, Jakarta**
Use: **Editorial**
Camera: **6x6cm**
Lens: **50mm and diffusion screen for upper part of picture**
Film: **Kodak Ektachrome EPN**
Exposure: **f/16**
Lighting: **Electronic flash: 5 heads and ambient light**
Props and set: **Location**

The key light, comes from camera right and illuminates the two men and the dramatic sculpture in the foreground: a pair of 600w-s heads above the screen on the right, one bounced into an umbrella and one in a standard reflector head.

General illumination comes from three heads bounced off the ceiling. One 300w-s unit is to camera right; a 600w-s unit is out of sight behind the elaborately carved wall behind the statue; and a 200w-s unit around the corner behind the two men lights that area. Finally, a modest 100w-s unit with a standard reflector back lights the tree behind the two men and provides general illumination in that part of the lobby. A partial diffusion filter softens the very top of the picture which might otherwise be too dominant a counterpoint to the men's white shirts.

► *Dramatic shapes like the sculpture normally demand dramatic, directional lighting unless they are photographed head-on in a very graphic, symmetrical way*

► *"Smear" filters — the classic way to make them is with a little petroleum jelly on a clear filter — can obscure irrelevant detail and focus interest on what is important*

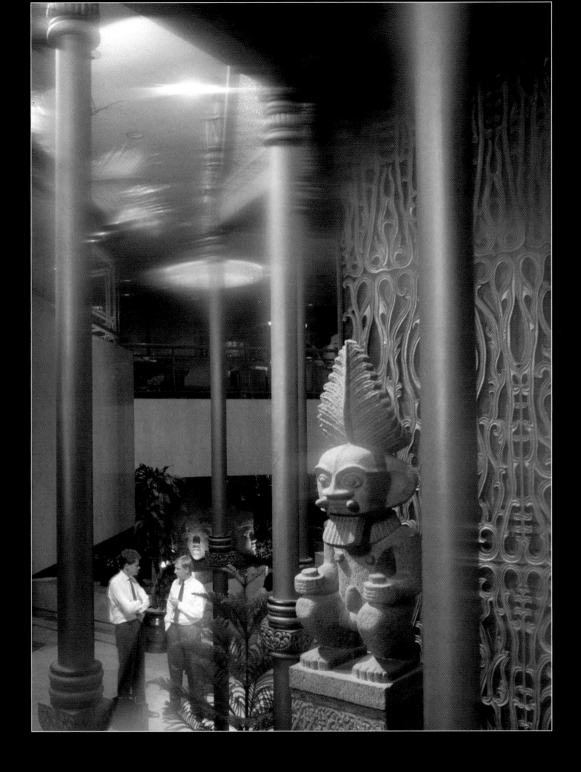

MULTI-LEVEL INTERIOR

▼

Lighting a multi-level location like this is always challenging, and one of the easiest ways to do it is to use a lot of lights. Here, Harry Lomax used five modestly-powered monoblocks with silver bounce umbrellas and six Morris heads (small domed units).

The camera is on the stairs, with three monoblocks and three Morris heads on the upper floor. The bigger units are to camera left, behind the railings on the left; on the stairs immediately to camera right; and beside the food bar on the extreme right. The small units are behind the drinks bar and food bar, and behind the railings on the left. On the ground floor are two more big lights to camera left and right, with two small lights behind the bar and one behind the pillar. In combination with this lot, a one-second exposure allowed the tungsten lights to register.

Photographer: **Harry Lomax**, Client: **Jackson Wallings Design**, Use: **Editorial**, Camera: **6x6cm**
Lens: **40mm**, Film: **Fuji RDP ISO 100**, Exposure: **1 second at f/11**, Lighting: **Electronic flash: 11 heads and tungsten**, Props and set: **Location**

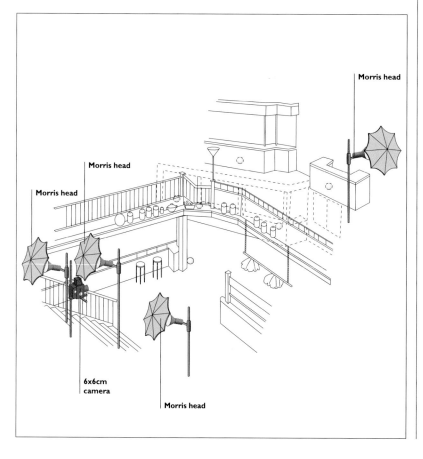

Morris head

Morris head

Morris head

6x6cm camera

Morris head

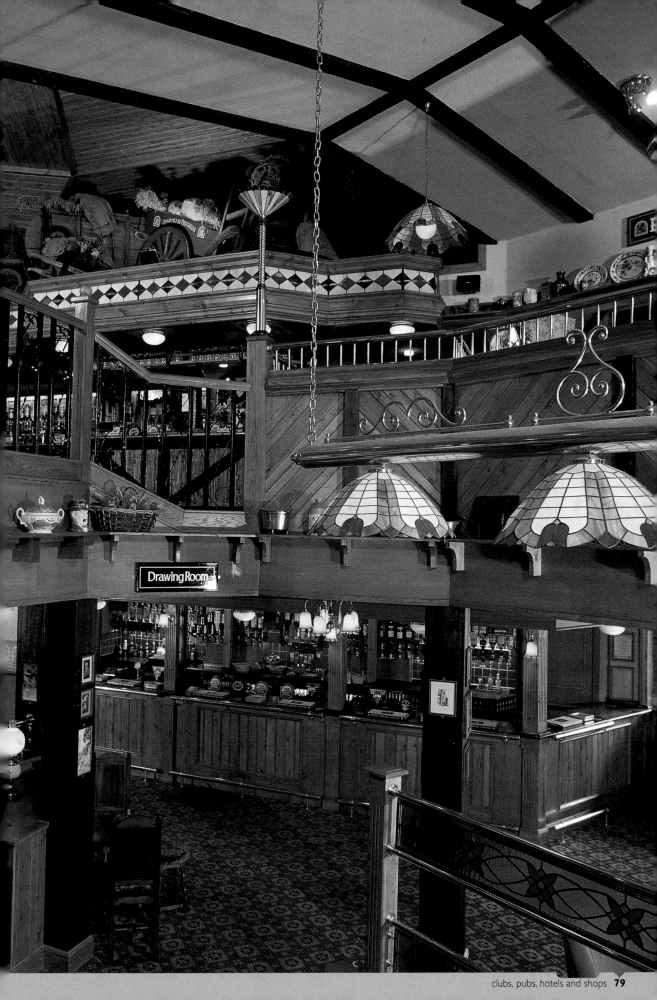

INN LEISURE

▼

THREE MONOBLOCK HEADS BOUNCED INTO SILVER UMBRELLAS; ONE SOFT BOX; AND FOUR SMALL MORRIS DOMED-HEAD UNITS RESTING ON THE FLOOR — A LOT OF LIGHTING! AND YET THE EFFECT IS SURPRISINGLY CLOSE TO THE AVAILABLE LIGHTING IN THE PUB.

Photographer: **Harry Lomax**
Client: **Inn Leisure Ltd**
Use: **Editorial**
Camera: **4x5 inch**
Lens: **75mm**
Film: **Fuji RDP ISO 100**
Exposure: **4 seconds at f/16**
Lighting: **Electronic flash: 8 heads plus ambient**
Props and set: **Location**

An umbrella flash to camera left and a big soft box to camera right are the starting points; the soft box is mounted particularly high, just under 4 metres (12 feet) off the floor. Another umbrella flash is concealed out of sight to camera left, and a third is mounted high (3 metres/10 feet) to light the back wall.

The small self-contained Morris heads are inside the bar; behind the bar; and in the raised seating area at the back of the room (both positions are from the camera point of view).

Once all this is in place, it is merely (merely!) a matter of choosing a shutter speed which records the tungsten lights pleasingly. Note also that the "starburst" on the light on the upper right is a result of a small aperture in a wide-angle lens; there is no filter.

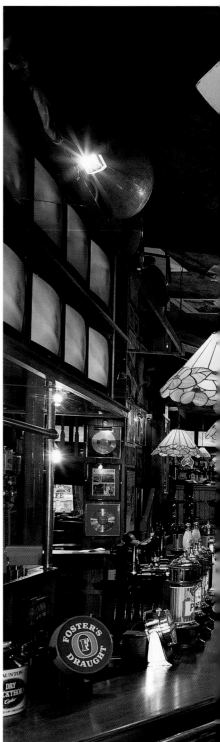

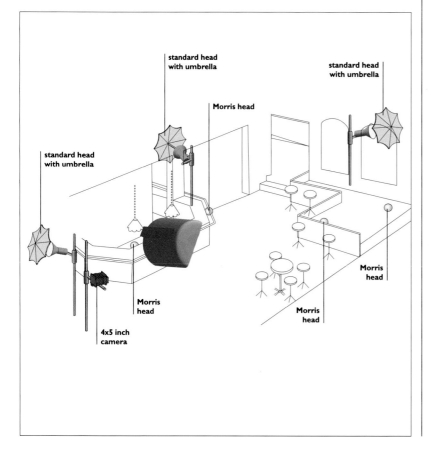

standard head with umbrella

Morris head

standard head with umbrella

standard head with umbrella

Morris head

Morris head

Morris head

4x5 inch camera

► Small units like the Morris heads need not have modelling lights; experience and Polaroid tests are an adequate guide to their use

► Neon signs like the DIET PEPSI sign record satisfactorily over an extraordinary range of exposures — three to five stops

Photographer's comment:

It was essential to retain the richness and warmth of this colourful interior.

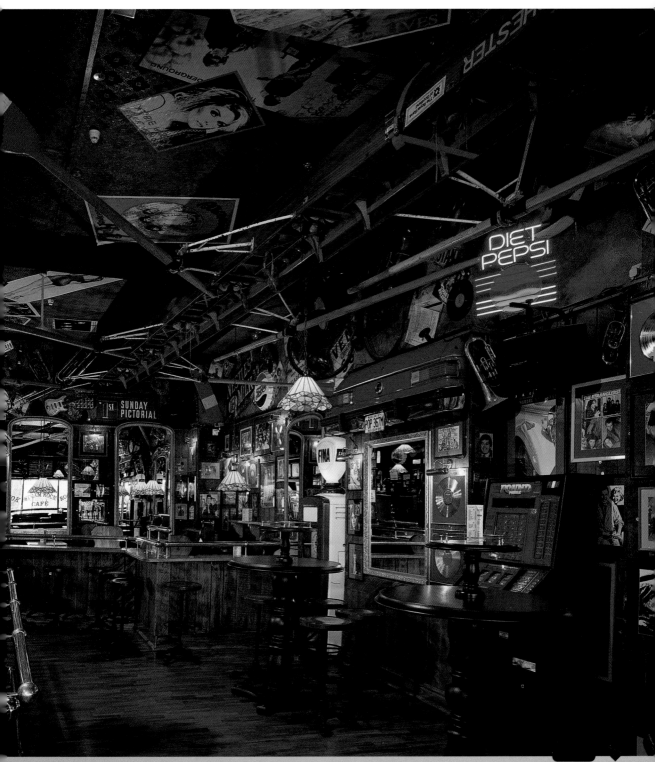

THE ENGINEER

▼

BOUNDARIES IN PHOTOGRAPHY ARE SELDOM CLEAR. IN THIS PICTURE, COMMERCIAL INTERIORS MEET REPORTAGE. FAST FILM AND THE 35MM FORMAT CREATE A SENSE OF IMMEDIACY, BUT THE PICTURE IS NOT QUITE AS SPONTANEOUS AND UNPLANNED AS IT SEEMS.

Photographer: **Jon Perugia**

Client: *Time Out Guides*

Use: **Editorial**

Camera: **35mm**

Lens: **28mm**

Film: **Kodak Ektachrome EPT pushed to EI 640**

Exposure: **1/8 second at f/4.5**

Lighting: **Modified available light – see text**

Props and set: **Location**

Although it is a real restaurant scene, and therefore had to be shot with the minimum of disruption and inconvenience to the patrons, the lighting has in fact been significantly modified. The key is the tungsten available light in the restaurant, but the photographer added candles to the tables and the "Christmas tree" lights in the background were moved from elsewhere in the restaurant. The pictures on the walls were moved specifically so that they would reflect interior lights – the exact opposite of normal practice – and there is a reflector just under the window to add a warm glow to the face.

The choice of a 28mm lens was dictated by the need to show as much of the restaurant as possible through the window, but without too much distortion in the hands and face. The longest practicable exposure in the circumstances was 1/8 second, which meant the only choice was f/4.5 even with the film pushed one stop to EI 640.

► Fast tungsten-balance films are rare; the normal options are "pushing" (as here) or fast print films with filtration

► The 28mm lens (very roughly the equivalent of 90mm on 4x5 inch) is as wide as one can normally go without risking wide-angle distortion

Photographer's comment:

Apart from the intimate quality of the lighting, the most important aspects of the picture are the structure imposed by the window frame and the sense of mystery created by the disembodied hand.

RESTAURANT

▼

BY USING TUNGSTEN LIGHT ON DAYLIGHT FILM, AND ALLOWING THE IMAGE TO HOVER ON THE EDGE OF OVEREXPOSURE, ROBIN CHANDA CREATED AN AMBIENCE WHICH IS BOTH LIGHT AND WELCOMING – WHICH WAS OF COURSE THE INTENTION OF THE RESTAURANT DESIGNER.

Photographer: **Robin Chanda**

Client: **Albany Hotel**

Use: **Brochure**

Camera: **6x7cm technical**

Lens: **65mm**

Film: **RDP**

Exposure: **8 seconds at f/16**

Lighting: **Available light supplemented with 2x 60W table lamps**

Props and set: **Location**

The majority of the lighting comes from the luminaries incorporated in the design of the restaurant; several are in shot, and (as always with light sources in shot) they are recorded very bright indeed. The only supplementary lighting came from a pair of Anglepoise desk lamps fitted with 60W bulbs, one either side of the camera, which provided fill in the lower part of the picture.

Although the photographer must always try to remain faithful to the intentions of the architect or room designer, there are conflicts between lighting for use and lighting for photography. In a restaurant, no-one needs the lower part of the tablecloth lit; in a photograph, if it were allowed to go dark, it would look very murky indeed.

Because the image was not to be run very large, it was shot on 6x7cm – but the camera in question was a "baby" Linhof which is in effect a smaller version of a 4x5 inch technical camera. An alternative approach would have been to use a roll-film back on a 4x5 inch camera.

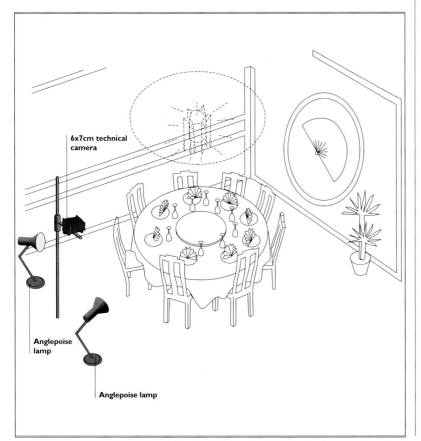

6x7cm technical camera

Anglepoise lamp

Anglepoise lamp

► *Photographic lights would have required filtration to make them match the colour of the ambient lighting, and there was no need for the extra power; desk lights were a better idea*

► *Without the dark centrepiece on the table there could have been an awkward "hot spot" in the middle*

Photographer's comment:

This was one of my first restaurant interiors, and I bracketed extensively to make sure I captured just the right exposure.

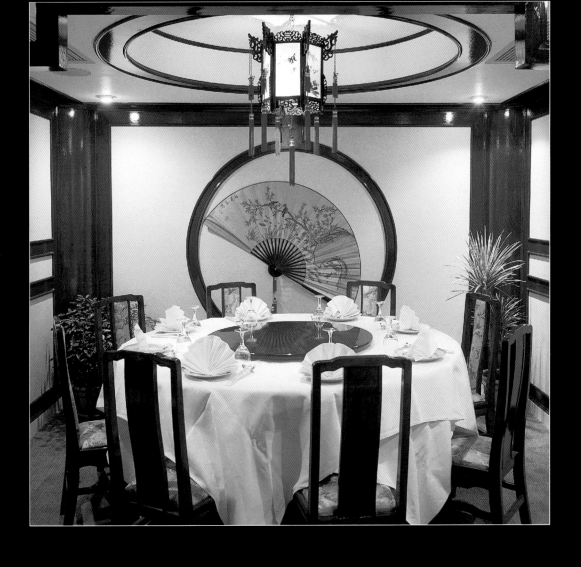

PUB RESTAURANT

▼

Photographer: **Harry Lomax**

Client: **Jackson Wallings Design**

Use: **Magazine**

Camera: **4x5 inch**

Lens: **75mm**

Film: **Fuji RDP ISO 100**

Exposure: **2 seconds at f/16**

Lighting: **Electronic flash: 6 heads plus ambient**

Props and set: **Location**

As with most successful indoor shots, it is hardly evident that there is any extra lighting in here, let alone six heads. The secret lies in allowing the windowlight to appear to dominate, and using the supplementary light as sophisticated and multi-directional fill.

A big soft box above the camera (about 2.4 metres/8 feet off the ground) provides the principal fill from the camera point of view, while two smaller units out of shot to the right supplement the windowlight from that direction: there is one "Soft Star" soft box and one bounced umbrella light, as shown. Both are again some eight feet off the ground. Finally, there are three more small, self-contained Morris dome-head lights placed as necessary to fill in a dark corner on the left (the light is behind the partition by the pictures) and to add highlights and a little more light from the right. This is the raised area of a larger room, and the camera is on the steps with a partition to the right. Because of the very wide angle of coverage of the lens, an aperture of f/16 provided adequate depth of field even on a 4x5 inch camera.

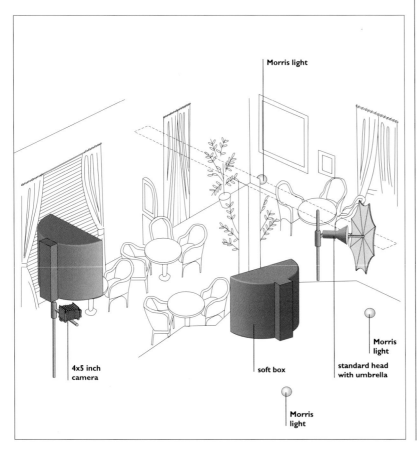

Morris light

Morris light

4x5 inch camera

soft box

standard head with umbrella

Morris light

Morris light

- ► Small heads like Harry Lomax's Morris units or Quintin Wright's "peppers" can make all the difference in small, dark corners

- ► Often, there is only one position from which you can shoot and you need the right lens for the job

- ► Slightly "burning out" the scene outside the shutters helps to disguise the fact that there is a car parked outside

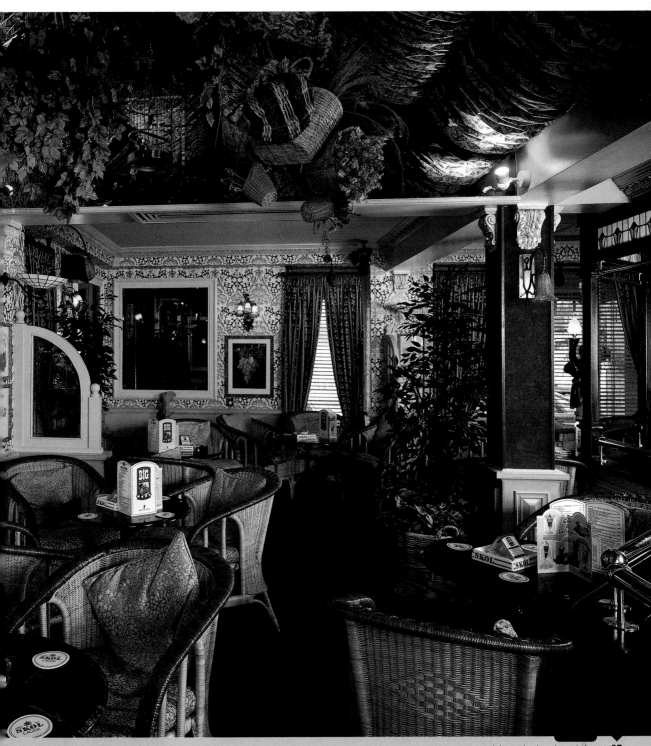

THE BENTALL CENTRE, LONDON

▼

ONE WAY TO HANDLE THE PROBLEM OF MOVING FIGURES DURING A LONG EXPOSURE IS SIMPLY TO LET THEM MOVE. THIS WILL NOT OFFEND MODERN SENSIBILITIES AND INDEED CAN ADD TO THE SENSE OF ENERGY AND DYNAMISM IN A PICTURE.

Photographer: **Brendan Anthony Walker**

Client: **Personal**

Use: **Exhibition**

Camera: **4x5 inch**

Lens: **90mm**

Film: **Kodak Ektachrome ISO 100**

Exposure: **1/2 second at f/45–1/3**

Lighting: **Available light**

Props and set: **Location**

In a busy place like The Bentall Centre, a totally static shot taken outside business hours would be lifeless and dull, but the blurring of the figures and the escalators conveys some of the energy of the place despite the relatively light traffic load. Also, lighting such a vast interior in such a way as to "freeze" all motion would call for unbelievable quantities of flash equipment, and would probably look unnatural anyway. You could do it with a 35mm camera and fast film, but then you would lose the detail and texture which is a large part of the attraction of the picture; it would be a mere snapshot.

It is also important to choose the right time of day for such an interior. This was shot at 14:30; had it been any later, the sun would not have created the wonderful mottled light on so many surfaces in the centre.

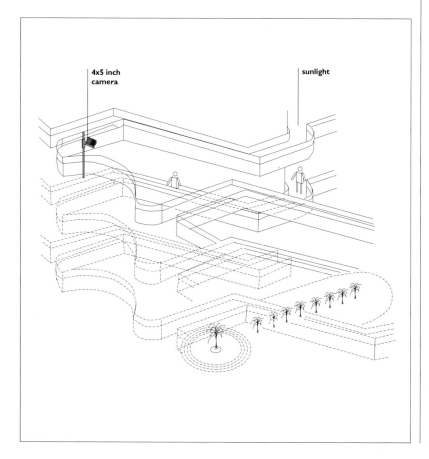

► Blurs caused by subject movement are not merely acceptable; in the right circumstances, they can contribute a good deal to a picture

► It would have been possible to shoot in ISO 400 (print) material and to reduce the exposure to 1/8 second, but blur generally works best when it is clear and obvious; if it were much less than this, it might merely look accidental

Photographer's comment:

I would like to thank the management of The Bentall Centre for allowing me access on a non-commercial shoot.

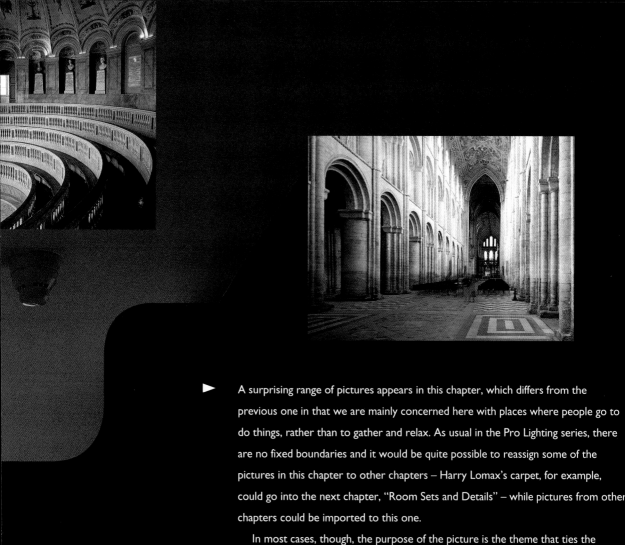

A surprising range of pictures appears in this chapter, which differs from the previous one in that we are mainly concerned here with places where people go to do things, rather than to gather and relax. As usual in the Pro Lighting series, there are no fixed boundaries and it would be quite possible to reassign some of the pictures in this chapter to other chapters – Harry Lomax's carpet, for example, could go into the next chapter, "Room Sets and Details" – while pictures from other chapters could be imported to this one.

In most cases, though, the purpose of the picture is the theme that ties the

ALMA TICINENSIS
UNIVERSITAS

▼

T HIS PICTURE CLEARLY REMINDS US WHY WE SAY, "AN OPERATING *THEATRE*" — THE LEGEND ON
THE PANEL READS "T HEATRUM A NATOMICUM", DENOTING A PLACE WHERE STUDENTS
WATCHED DISSECTIONS. T HE SOLE ADDED LIGHT IS A LARGE TUNGSTEN BANK TO CAMERA LEFT.

Photographer: **Francesco Bellesia by Wanted**
Client: **Università degli Studi di Pavia**
Use: **Book**
Art directors: **Francesco Bellesia and Roberto
Benzi**
Camera: **4x5 inch**
Lens: **90mm**
Film: **Kodak Ektachrome 64 EPR**
Exposure: **10 seconds at f/22**
Lighting: **Tungsten bank**
Props and set: **Location**

The choice of tungsten lighting and
daylight-balanced film, without any
compensatory filtration, is unexpected for
this shot but adds to the air of antiquity:
it echoes the musty darkness of another
age, as well as recalling the yellowing
varnish which covers (and often
disguises) the colours of so many old
paintings. The intensity of the light bank
well balances the lights at the tops of the
pillars, which are just burned out, as they
appear to the naked eye.

The height of the light bank is
important: if it had been too low, the
detail of the benches would not have
been revealed.

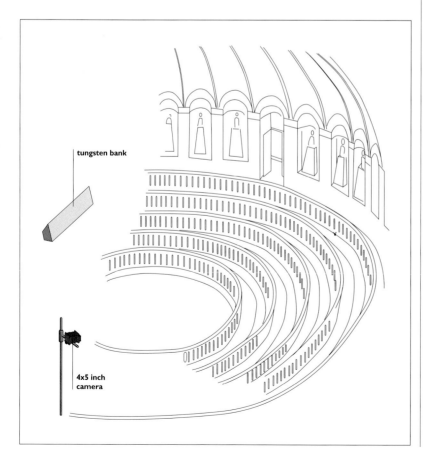

tungsten bank

4x5 inch
camera

► *The 90mm lens has "pulled" the*
perspective somewhat; this is as wide as
one could conveniently go, though the
widest lens which covers 4x5 inch is
47mm

► *The "starbursts" around light sources*
are reflections from the edge of the lens
diaphragm

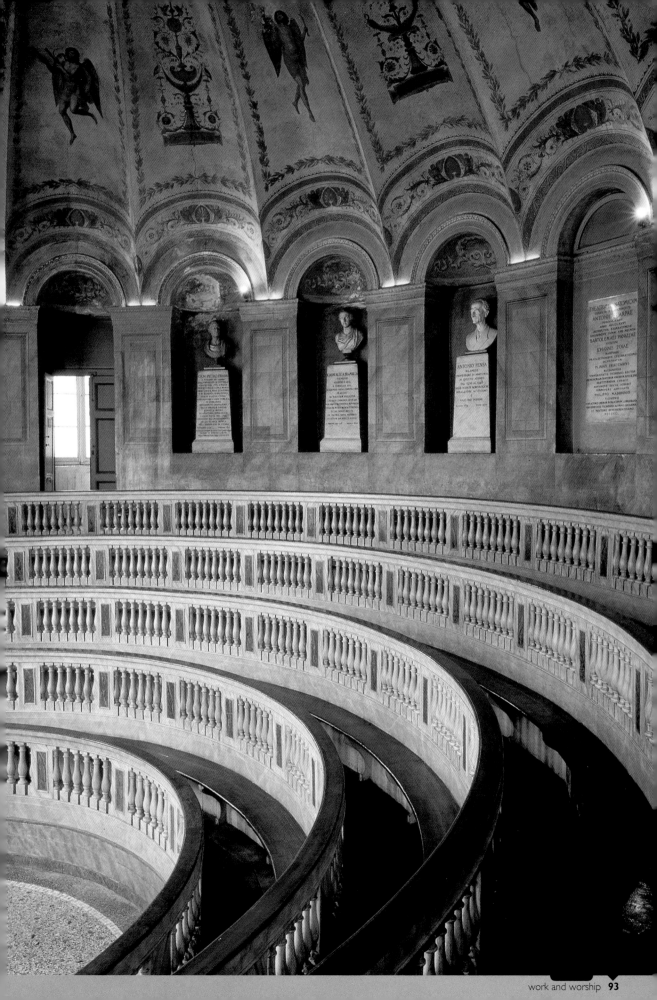

LOBBY WITH SUNBURST TABLE

Photographer: **Tim Edwards**

Client: **D.V.D. International**

Use: **Record**

Camera: **4x5 inch**

Lens: **90mm**

Film: **Fuji RTP Tungsten**

Exposure: **8 seconds @ f/22-1/2**

Lighting: **Tungsten**

▼

THE LIGHTING HERE IS ESSENTIALLY AVAILABLE LIGHT, AND NOT MUCH OF IT, TOGETHER WITH A DIFFUSED REDHEAD (TUNGSTEN-HALOGEN LAMP) THROUGH THE DOOR ON THE RIGHT. THERE ARE INEVITABLY SOME CROSSED SHADOWS, BUT THESE ARE NOT ALWAYS THE SIN IN ARCHITECTURAL PHOTOGRAPHY THAT THEY ARE ELSEWHERE.

The principal lighting, in keeping with the architect's plans, comes from the ceiling-mounted tungsten lamps and from the daylight outside. Even with the blinds drawn, the window is on the edge of burning out, which is entirely natural-looking and which also disguises the blueness of the daylight: colour is only recorded across a maximum of four or five stops (16:1 to 32:1) but outside this range colour films can still record a surprising range of tones.

The light shining through the door on the right is however comparable in intensity to the overall lighting: brighter, but not glaring. If it were balanced to tungsten, it would be very cold and unpleasant-looking. Without it, the right-hand side of the picture would be very murky indeed.

4x5 inch camera

standard head

► *Tungsten light is normally seen as warm and welcoming: daylight is perceived as cooler and more refreshing*

► *Before deciding whether to use daylight-balanced or tungsten-balanced lighting, consider the psychological impact*

► *The stars around the lamps are reflections from the lens diaphragm*

Photographer's comment:

It is difficult to capture adequate detail in low-light interiors while still capturing the feel of the architect's lighting spec.

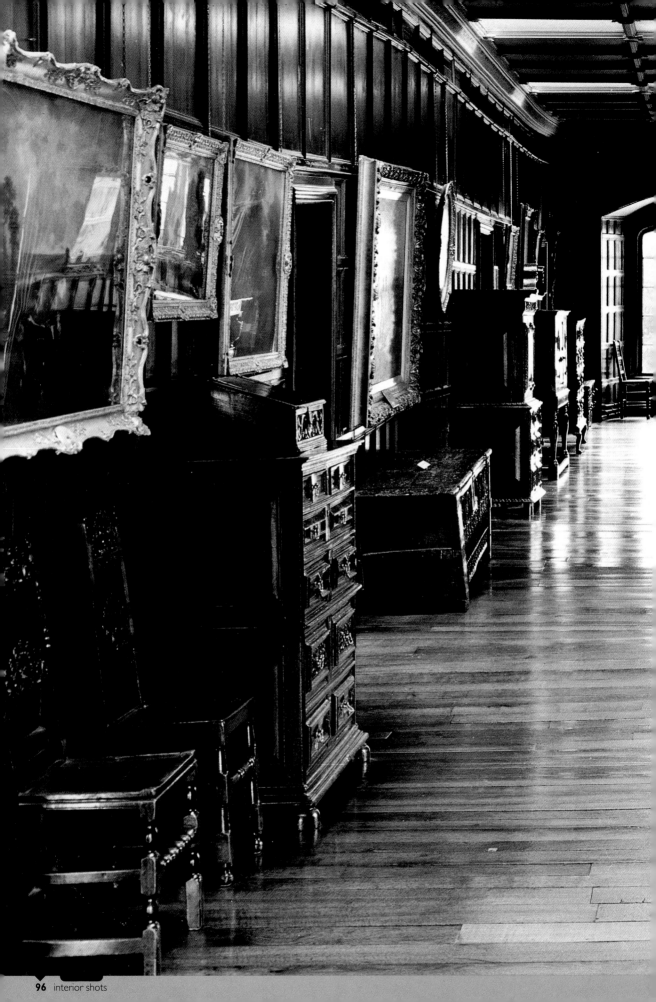

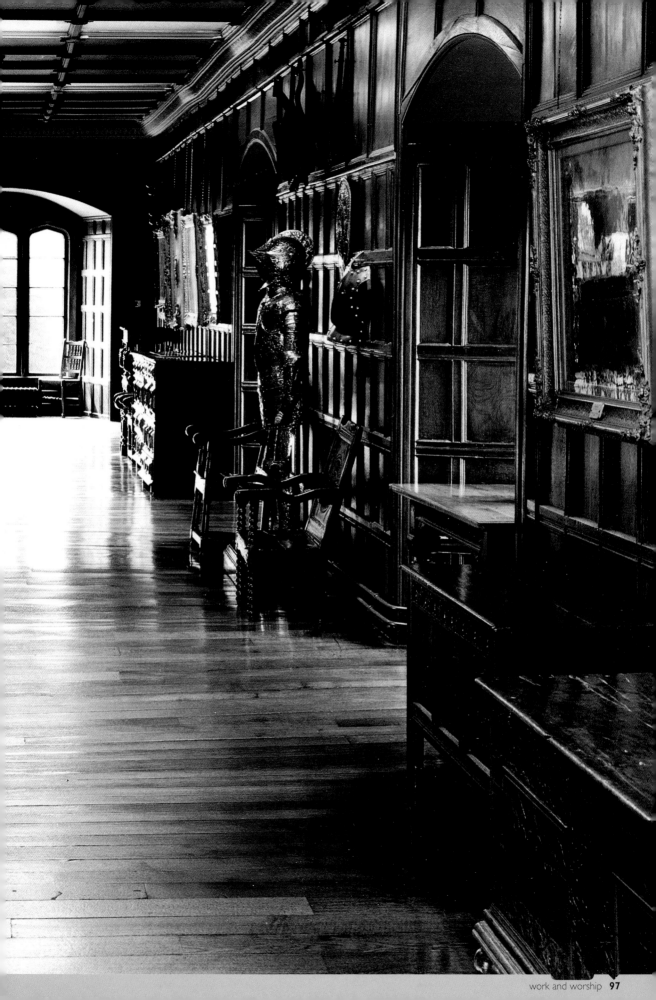

TOWNLEY HALL

▼

Photographer: **Brendan Anthony Walker**

Client: **Personal**

Use: **Exhibition**

Camera: **4x5 inch**

Lens: **90mm**

Film: **Ilford Delta 400 Professional**

Exposure: **1 minute at f/22**

Lighting: **Available light plus two 500W floods**

Props and set: **Location by kind permission of Susan Bourne, Curator, Townley Hall, Burnley, Lancashire, England**

THE TIMELESSNESS OF ANCIENT INTERIORS CAN BE WELL SERVED BY THE TIMELESSNESS OF BLACK AND WHITE – AND MONOCHROME ALSO REMOVES POTENTIAL PROBLEMS WITH MIXED LIGHT SOURCES, WHICH DO NOT HAVE TO BE "GELLED OFF." HERE, DAYLIGHT IS SUPPLEMENTED WITH FLUORESCENT LIGHTS AND TUNGSTEN.

The daylight from the window at the end, and through the door to the right, is clearly the key. The deeper one penetrates into the hall, however, the darker it gets. The ceiling-mounted fluorescent lights are visible in the shot, while the photographer used two tungsten lights – one either side of the camera – to supplement the light still further.

What is particularly noteworthy is that while the long tonal range of monochrome has avoided the blocked-up shadows and burned-out highlights which would have been inevitable with colour, one of the reasons the picture is so successful is the reflections off the polished wood and the window frames. These are what give a real feeling of three-dimensionality and depth. With extreme care in printing, and all lights "gelled off" to match daylight, it might just have been possible to shoot this on colour negative.

► *Even apparently dark interiors may have numerous strongly reflective highlights*

► *Using pos/neg processes instead of transparency material gives additional potential for control at the printing stage*

► *Monochrome is often well suited to pictures of historical interiors*

Photographer's comment:

I could have placed more lights strategically along the gallery but I felt that this would have looked unnatural and would spoil the ambience I was trying to portray.

ARGENTARIA BANKING FLOOR

▼

THIS IS AN ELECTRONIC COMPOSITE OF 13 PICTURES OF PEOPLE AND A "FLOOR" WHICH IS ONLY ABOUT 240x120CM (8x4 FEET). THE PEOPLE WERE SHOT IN GROUPS FROM A HIGH GANTRY, USING CONGRUENT TRIANGLES TO SCALE THE PERSPECTIVE.

The "floor" was lit hanging on the wall. It was lit from each corner with a soft box, with polyboard bounces on all four sides for very even lighting. A gobo'd focusing spot created the sunlit effect; getting the light beams parallel was hard work.

The people were then photographed individually or in groups of up to four, as they appear in the picture. They were lit as evenly as possible, using banks of high-mounted soft boxes. The "shadows" on the floor were added electronically (and are matched to whether the figure is in "sun" or "shade", but the internal shadows in each group (look at the material on the desk) show the top lighting. The camera stayed in position, while the models were posed at different distances from a point immediately below the camera; the floor was marked in "scale metres" so that the perspective would match the concept of the picture. Look at the chairs in opposite corners of the set to see how successful this was.

Photographer: **Jay Myrdal**

Client: **Klein Grey for Argentaria**

Use: **International press**

Models: **The staff of Klein Grey advertising agency**

Assistant: **Peter Day**

Art director: **Vic Hazeldine**

Camera: **8x10 inch and 6x6cm**

Lens: **360mm (8x10 inch); not recorded (6x6cm)**

Film: **Kodak Ektachrome EPP**

Exposure: **f/22 (8x10 inch); not recorded (6x6cm)**

Lighting: **Electronic flash: 4 soft boxes and projection spot (8x10 inch); large soft boxes (6x6cm)**

Props and set: **"Floor" made by Steve Cook**

First exposure

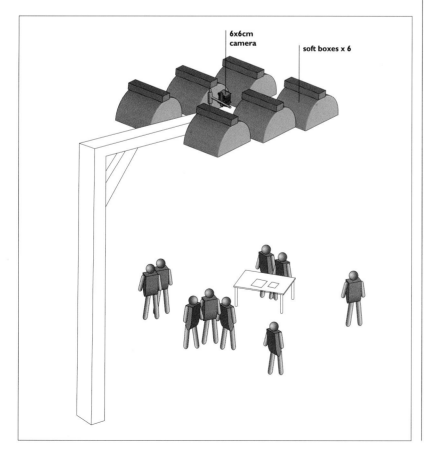

► *Perspective depends upon viewpoint; and unless pains are taken to keep perspective constant, "comped" shots will always look artificial*

► *Diffuse overhead lighting of the individual groups removes the problem of conflicting shadows inside the groups and in the picture as a whole*

► *Most people will never notice the above attention to detail – but there are always those who will*

COURAGE

▼

THERE IS A SURPRISING AFFINITY BETWEEN BANKS AND PUBS – PERHAPS IT IS SOMETHING TO DO WITH THE MONEY THEY BOTH TAKE IN – AND THIS IS AN OLD BANK (A LISTED BUILDING, AT THAT) WHICH HAS BEEN CONVERTED TO A PUB.

Photographer: **Harry Lomax**

Client: **Courage Ltd.**

Use: **Editorial**

Camera: **4x5 inch**

Lens: **75mm**

Film: **Fuji RDP ISO 100**

Exposure: **4 seconds at f/16**

Lighting: **Electronic flash: 13 heads plus ambient**

Props and set: **Location**

There is a great deal more lighting here than is immediately apparent: one soft box, five umbrellas, two bare-bulb standard heads, and five small self-contained Morris units on the floor.

The main lighting from the camera point of view is a soft box over the camera, about 2.5 metres (8 feet) high; an umbrella to camera left, at about the same height; and another umbrella to camera right, about 4.5 metres (15 feet) high. Two more umbrellas, one above the other, are concealed behind the

massive pillar near the centre of the picture and yet another umbrella is behind the further pillar. Bare-bulb heads are concealed behind two more pillars, as shown in the drawing. Finally, five small self-contained units on the floor make up the total of 13 heads.

Despite all this, the room is not over-lit, though Harry Lomax adds, ''Please note, shadows from hanging lights in the foreground were from a 'scenic spot' and not my lights.''

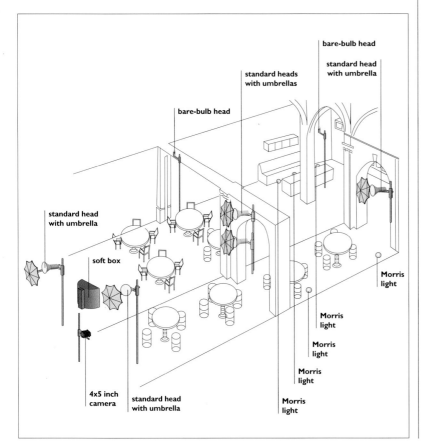

standard heads with umbrellas

bare-bulb head

standard head with umbrella

bare-bulb head

standard head with umbrella

soft box

Morris light

Morris light

Morris light

Morris light

4x5 inch camera

standard head with umbrella

Morris light

► *The photographer normally has only to avoid overwhelming the architect's lighting plan; but when the lighting is a feature (especially the roof light) he is even more constrained*

► *Television screens provide a special problem: too short an exposure and they record with a stripy image, too long and they burn out*

Photographer's comment:

The ceilings and TV screens were essentials, as were the lighting effects such as the lights within the pillars.

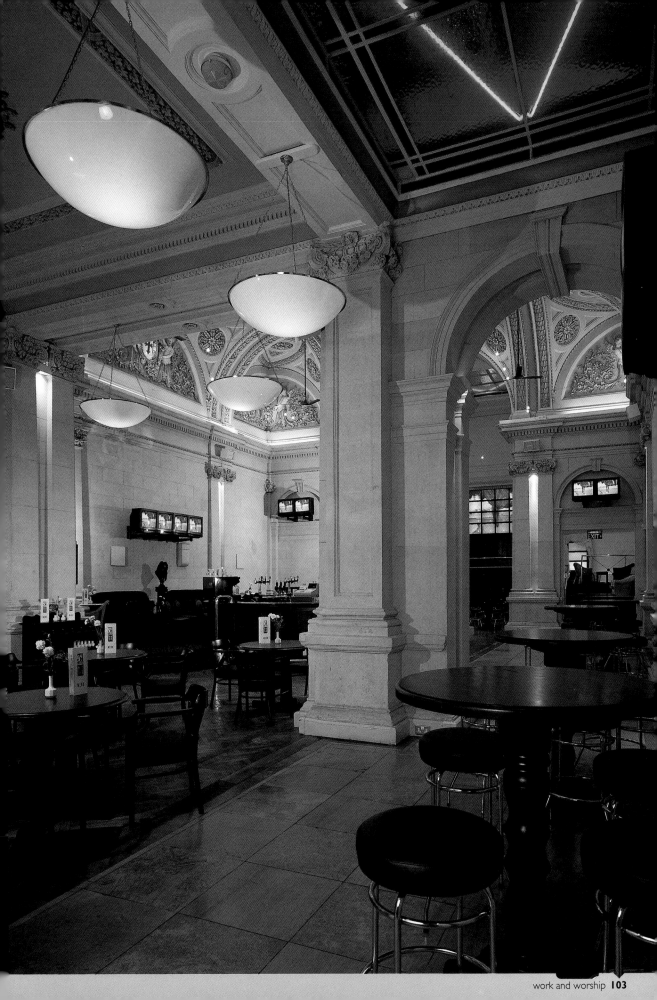

CONFERENCE ROOM

▼

A CONFERENCE HALL HAS TO LOOK BRIGHT ENOUGH TO WORK IN WITHOUT BEING CLINICAL, AND WELCOMING WHILE STILL REMAINING BUSINESSLIKE; THE WOOD-BEAMED ROOF AND THE WOOD PANELLING ARE OBVIOUSLY VERY IMPORTANT.

Photographer: **Harry Lomax**

Client: **Paragon Design**

Use: **Magazine**

Camera: **4x5 inch**

Lens: **75mm**

Film: **Kodak EPP Readyload**

Exposure: **4 seconds at f/16**

Lighting: **Electronic flash: 6 heads plus ambient**

Props and set: **Location**

Two lights to camera left provide the main illumination, a soft box about 4.5 metres (15 feet) off the floor and a bounced umbrella just by the entrance at about 3 metres (10 feet). Two more bounced umbrellas in the side rooms create an impression of still more light; if the side rooms were not lit, they would have registered as black holes. A bare-bulb head just under the rafters to camera right, immediately out of shot, lightens the brickwork and the roof in an otherwise very dark corner. Finally, a small Morris self-contained unit on the floor, just on the far side of the near table, lightens the floor area.

There is of course quite a lot of ambient light too, and this is on the point of burning out – but only on the point. It is always more welcoming to record the lights in shot as a little brighter than they are (by means of a longer exposure) rather than recording them as too dim.

standard head with umbrella

soft box

standard head with umbrella

bare-bulb head

Morris light

standard head with umbrella

4x5 inch camera

► *Modern interiors are often far less dependent on natural light than buildings designed in the days before electric lighting*

► *Note the places laid for a meeting, with water glasses, pads, pencils etc. Without these, the location would look very bleak indeed*

Photographer's comment:

It was important to show to good effect both the main conference room and the adjoining syndicate rooms.

CARPET

▼

THIS IS AN ASSIGNMENT TO MAKE THE HEART SINK: PHOTOGRAPH A CARPET TO MAKE IT LOOK INTERESTING (THE CLIENT IS A CARPETING SUPPLIER). BY ITS NATURE, A CARPET IS OFTEN LARGE, FLAT AND REPETITIVE – SO THE ONLY WAY TO ADD INTEREST IS BY LIGHTING.

Photographer: **Harry Lomax**
Client: **Rudge Bros. & Jones**
Use: **Editorial**
Camera: **4x5 inch**
Lens: **75mm**
Film: **Fuji RDP ISO 100 Readyload**
Exposure: **4 seconds at f/16**
Lighting: **Electronic flash: 5 heads plus ambient**
Props and set: **Location**

What is more, carpets absorb a surprising amount of light, in much the same way as an animal's pelt. You therefore need plenty of light, but you need to be careful not to burn out the rest of the room at the same time.

This is why there are four large heads and a small one. Behind the camera and slightly to the left there is a big soft box, pointing downwards from about 2.5 metres (8 feet). A head bounced into an umbrella is cantilevered out at ceiling height; this contributes one of the pools of light on the carpet. Another comes from a bounce umbrella in a passage off to the right, just about opposite the table, and the third comes from a little Morris self contained head hidden in an alcove just before the far entry. The last unit is again a bounced umbrella flash in the far corridor, from camera right.

► *Anything with a pile – fur, rugs, hair – absorbs a lot of light*

► *Using "pools" of light on an otherwise monotonous and repetitive background adds interest*

► *A wide-angle lens brings the carpet out to meet the viewer and welcomes him into the picture*

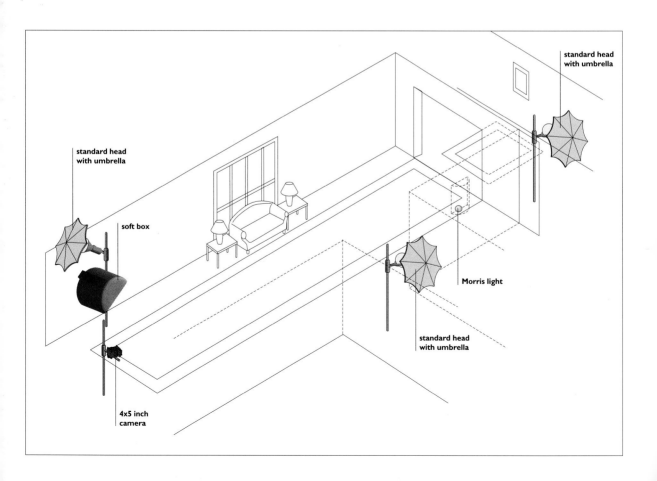

standard head with umbrella

standard head with umbrella

soft box

Morris light

standard head with umbrella

4x5 inch camera

ELY CATHEDRAL

▼

THE INTERIORS OF CHURCHES AND CATHEDRALS ARE OFTEN EXTREMELY BEAUTIFUL, AND THEY HAVE LONG BEEN AN INSPIRATION – AND A CHALLENGE – TO PHOTOGRAPHERS. THE PROBLEMS ARE TWOFOLD: LOW LIGHT LEVELS AND ENORMOUS HEIGHT.

Photographer: **Quintin Wright**

Client: **Encyclopaedia**

Use: **Educational**

Camera: **4x5 inch**

Lens: **75mm with 2-stop graduated filter**

Film: **Fuji RDP ISO 100**

Exposure: **30 seconds at f/32**

Lighting: **Available light**

Props and set: **Location**

It is possible to light the interior of a cathedral, but it is not easy. The easiest way is probably with large numbers of powerful flashbulbs. The other approach is to use available light with very long exposures. Before World War Two it was quite normal to set up the camera with the lens at f/64; uncap the lens; and then adjourn to the nearest public house for lunch during the exposure. This is all right with monochrome, but in colour the windows will burn out long before the darker areas have begun to register.

Quintin Wright solved the problem simply and ingeniously with a 2-stop graduated neutral density filter, which is of course normally used for skies. Together with a modern wide-angle lens, used with a good deal of rise and a certain amount of front swing (the camera back looked straight at the altar, but the lens looked to the right), this sufficed for a 30-second exposure on ISO 100 film.

4x5 inch camera

► *ND grads vary widely in maximum density, steepness of gradation, and even colour; cheap filters may introduce colour casts*

► *Big flashbulbs are still available (they are made in some Third World countries) but they are expensive and they have to be replaced after each shot – and the flash guns generally have to be found second-hand*

PASTEL LOBBY

▼

WHEN YOU HAVE A SUFFICIENTLY LIGHT INTERIOR LIKE THIS ONE, IT ACTS AS A LARGE MIXING CHAMBER AND BOUNCES LIGHT AROUND INTERNALLY TO CREATE A SURPRISINGLY EVENLY ILLUMINATED SCENE. THERE IS NO SUPPLEMENTARY LIGHTING IN THIS PICTURE.

Photographer: **Tim Edwards**

Client: **Switch Design**

Use: **Property brochure**

Camera: **4x5 inch**

Lens: **65mm**

Film: **Fuji RDP ISO 100**

Exposure: **2 seconds at f/22-1/2**

Lighting: **Available**

Props and set: **Location**

The artificial light sources – principally the uplighters – are not a problem as the colour of the lobby interior means that they record fairly neutral anyway, while the generous windows admit plenty of daylight. One might criticise the dark space under the clock, but if it were any lighter the picture would lose balance and the impact of the sun-faced clock would be significantly less. Also, the darkness emphasizes the fact that this is a lobby, a transition between the street outside and the building within. This is one of the few pictures in the book which was shot with a 65mm lens, but the only real clue to the extreme angle of coverage is to be seen in the ceiling. Properly aligned, even extreme wide-angles can look surprisingly natural, though shapes are inevitably distorted. It is interesting that modern readers can accept perspectives which fifty years ago would have been condemned as "violent".

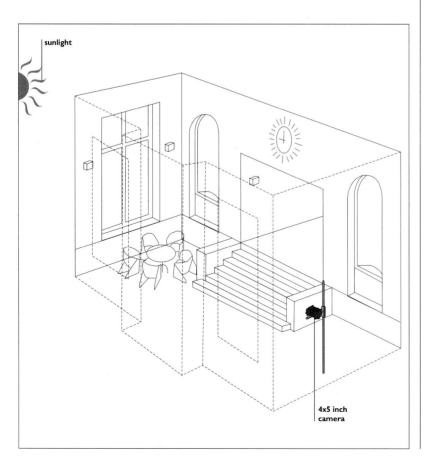

sunlight

4x5 inch
camera

► Lighting for ultrawides can be a problem, simply because of the areas to be covered and the need to keep the lights out of shot, so available light is better whenever possible

► Both visual alignment and alignment using a spirit level are essential when using extreme wide angles

Photographer's comment:

I was not worried about the interior lights, as they went quite neutral. The interior was quite light anyway, as evidenced by the short exposure.

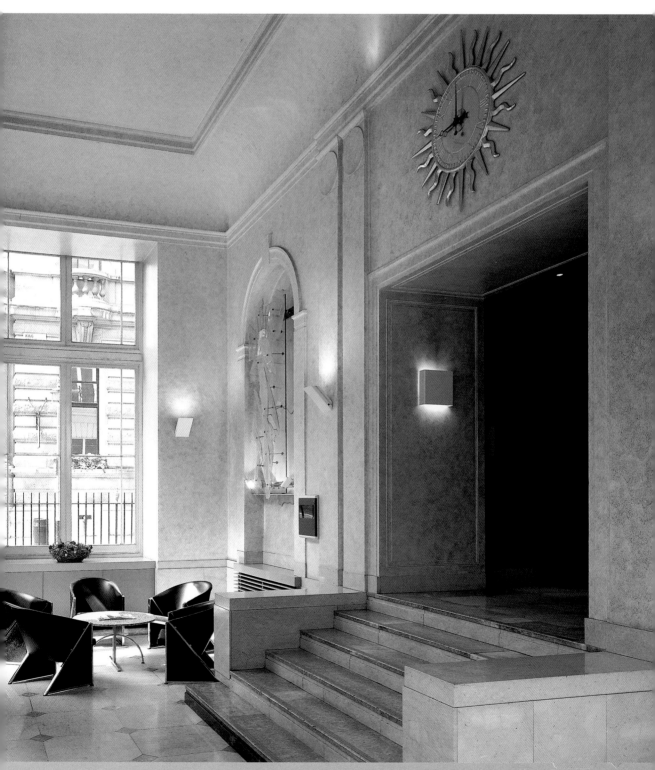

ARCHED DOOR

▼

Photographer: **Tim Edwards**
Client: **Fitzroy Robinson**
Use: **Record**
Camera: **4x5 inch**
Lens: **90mm with 80A filter**
Film: **Kodak Ektachrome EPP ISO 100**
Exposure: **10 seconds at f/22-1/2**
Lighting: **Available light**

Partial filtration – "splitting the difference" between daylight and tungsten – is not something to be undertaken lightly but it can work very well indeed, as this picture shows. If you do it, then lean decisively towards one or the other.

A Wratten 80A filter or equivalent corrects 3200°K tungsten light to daylight; a 15 decamired shift. But the tungsten lights in this photograph burn from about 2600°K to 3000°K, and therefore read very slightly yellow. The daylight from windows on either side of the door therefore reads as very blue indeed – which is an extremely dramatic effect, still further emphasizing the symmetry of the setting.

If the lighting had not been symmetrical, it would have been a very different matter: the choice would have been between taping gel filters over the window on one side, to bring its colour temperature up to the equivalent of tungsten light, or of lighting the other side with diffused flash so as to preserve the blueness.

Although few photographers own them, many other blue colour-correction filters are made with decamired shifts of 1 to 19; a B+W KB12, for example, is designed to correct weak incandescent lamps (up to 60W) to daylight balance.

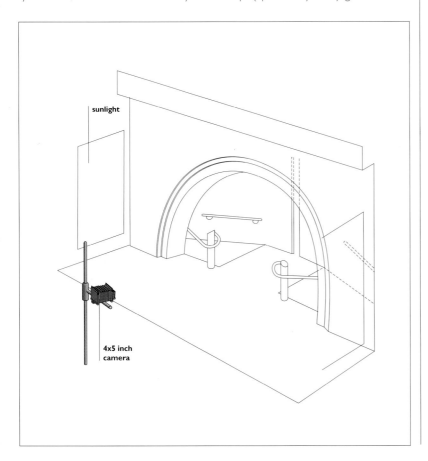

sunlight

4x5 inch
camera

► *Study filter manufacturers' catalogues to see what is available*

► *Consider shooting three pictures: with filtration, without filtration, and with partial filtration, just to see what happens*

► *If you need filtration, but you do not have anything strong enough, use what you do have*

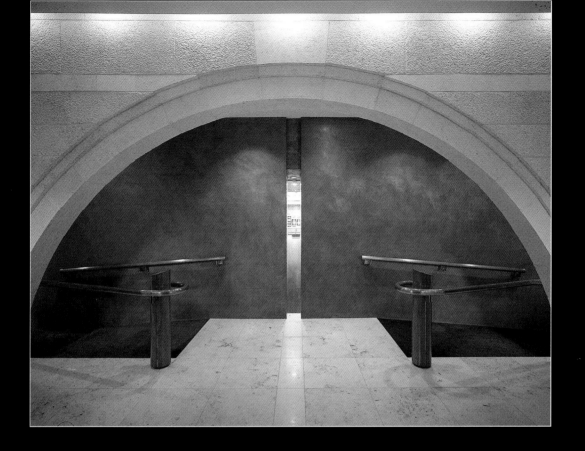

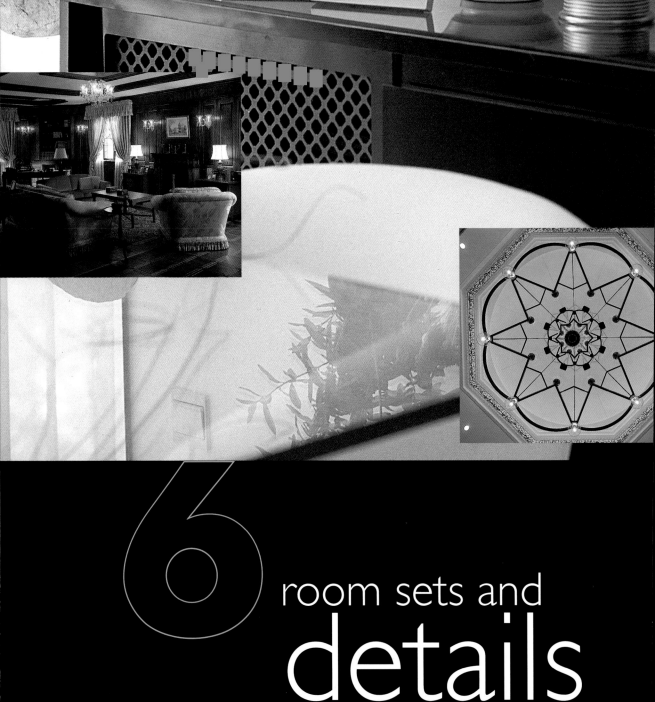

6 room sets and details

To say that the pictures in this chapter are the most contrived in the book is not to belittle them: rather the opposite. There are in effect two separate strands here, one which imposes a formality of vision by selecting a relatively small part of an interior and concentrating our attention on that – a good illustration of the dictum that "less is more".

Relatively few photographers are ever going to photograph fully built sets on the scale of Kenichi Ura's Matsushita room set or David Watts' kitchen, let alone the surrealism of Jay Myrdal's picture on page 135, but it is intriguing to know how such sets are built and lit – and, of course, the techniques of lighting built sets can sometimes be adapted to location shoots. On the other hand, built sets are more often lit with tungsten than with flash, simply because it is easier to use long exposures with a continuous light source than to use either enormous quantities of flash or even multiple "pops" with less powerful flash.

When it comes to details, though, there is as much to be learned from the photographer's selection of viewpoint and focal length as there is to be learned from the lighting diagrams – though these can also reveal unique problems, as in Tim Hawkins' picture of "the infinity room".

FORMAL STAIRCASE

▼

Photographer: **Tim Edwards**

Client: **Ampersand Ltd.**

Use: **Brochure**

Camera: **4x5 inch**

Lens: **90mm**

Film: **Fuji RTP tungsten-balance**

Exposure: **4 seconds at f/22-1/2**

Lighting: **Electronic flash: I head, filtered**

THE DOMINANT LIGHT HERE IS CLEARLY THE CEILING FITTING IN THE MIDDLE OF THE PICTURE, THOUGH THE LIGHTS BEHIND THE STAIRCASE ALSO CONTRIBUTE A GREAT DEAL TO THE IMPACT OF THE PICTURE. THE LIGHT AT THE TOP OF THE STAIRCASE IS MUCH COOLER, BECAUSE IT IS DAYLIGHT FROM THE ATRIUM ABOVE.

All of this reflects the architect's lighting plan, but (as so often) a helping hand was required to remove discrepancies between what the eye sees, and what the camera sees. The symmetry of the subject clearly demands symmetrical lighting, and the left-hand side was darker than the right. A flash head, filtered to tungsten balance, was bounced off the ceiling to camera left.

The shot was taken through a door which limited the camera position, and this meant that the legs of an antique globe on the extreme left appeared in the picture (they may have been cropped in reproduction here). Normally, one would either remove this, or move it into shot, but it was too fragile and was therefore left in position.

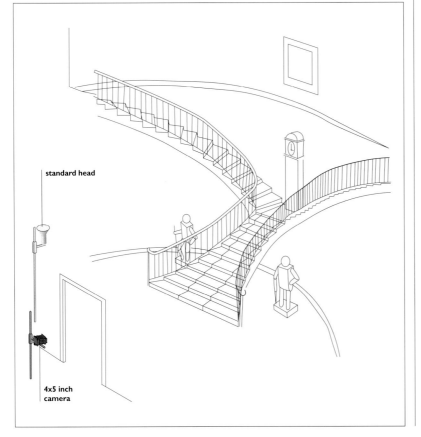

standard head

4x5 inch camera

► *A wider lens (75mm or 72mm) would have exaggerated the perspective on the stairs too greatly, as well as distorting the globe on the left*

► *Provided the contrasts are not too glaring, mixed daylight and tungsten lighting can accurately reflect the architect's intentions*

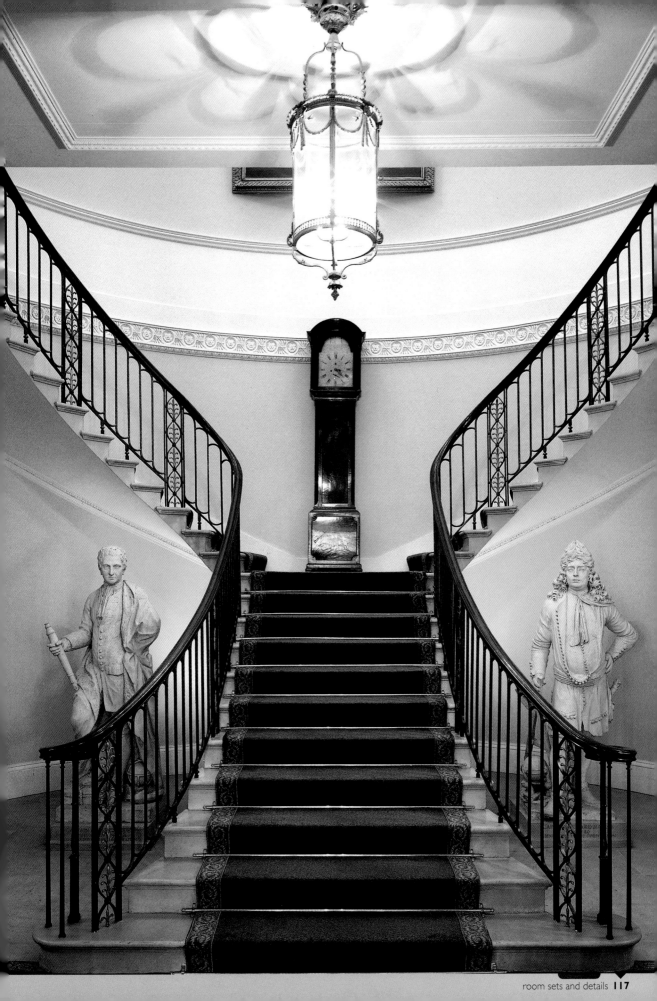

MOSQUE CEILING

▼

THE ILLUMINATION IS AS SYMMETRICAL AS THE SUBJECT: SIX TUNGSTEN FOCUSING SPOTS WERE ARRANGED IN A RING AROUND THE CAMERA (WHICH WAS LOOKING STRAIGHT UPWARDS) AND BOUNCED UPWARDS OFF THE WALLS TO INCREASE THE OVERALL LEVEL OF ILLUMINATION INSIDE THE MOSQUE.

Photographer: **George Solomonides**
Client: **Carnell Green Partnership**
Use: **Client's portfolio**
Camera: **4x5 inch**
Lens: **65mm**
Film: **Kodak Ektachrome 64 tungsten-balance (6118)**
Exposure: **f/22; speed not recorded**
Lighting: **Tungsten: 6 heads**

Using tungsten lighting also allowed the lights in the ceiling to read as white instead of very yellow – though they are actually slightly yellower than photographic lights. The chosen aperture, f/22, is the normal working aperture for the old 65mm Super-Angulon when used on the 4x5 inch format; the shutter speed was chosen to suit this. At wider apertures, the grid work in the corners might not have been in focus, or coverage might have been marginal. The large format allows the calligraphy around the octagonal surround to the dome to be read easily.

Getting the camera close to the floor and looking straight up necessitated a boom arm under the tripod. Low-angle pictures, and especially low-angle pictures looking straight up, are something which catch most photographers out once – but only once, if they learn from their errors. There are several different solutions; a boom arm is only one.

standard head

standard head

standard head

4x5 inch camera

standard head

standard head

standard head

► *Extreme wide-angle lenses will not cause obvious distortions in a radially symmetrical subject if they are properly centred*

► *Wider lenses are available for 4x5 inch than for any other format*

► *Camera mounts which permit operation very close to the floor are sometimes necessary*

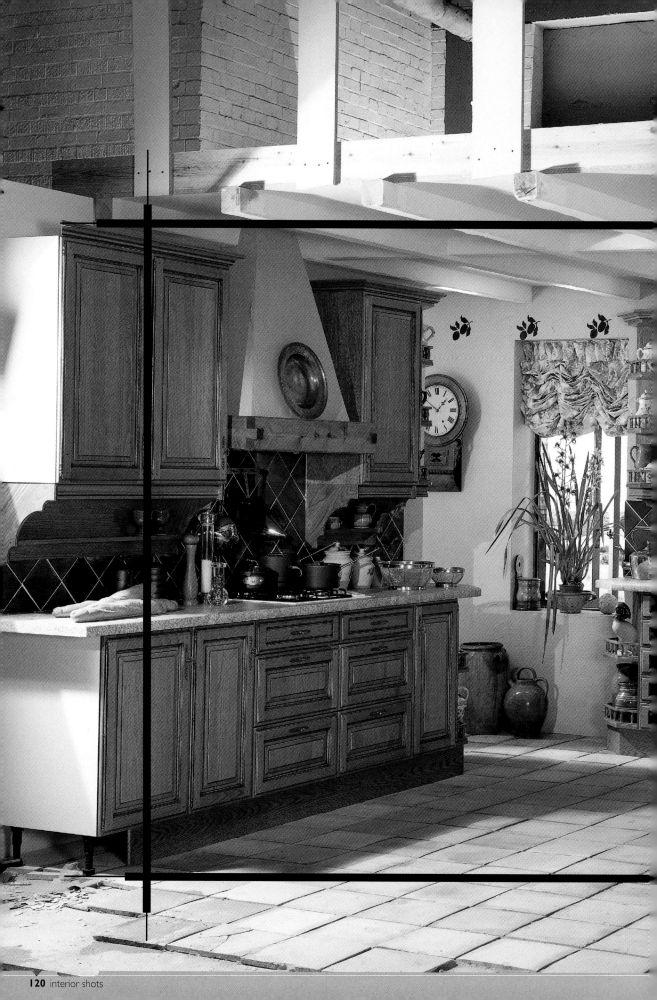

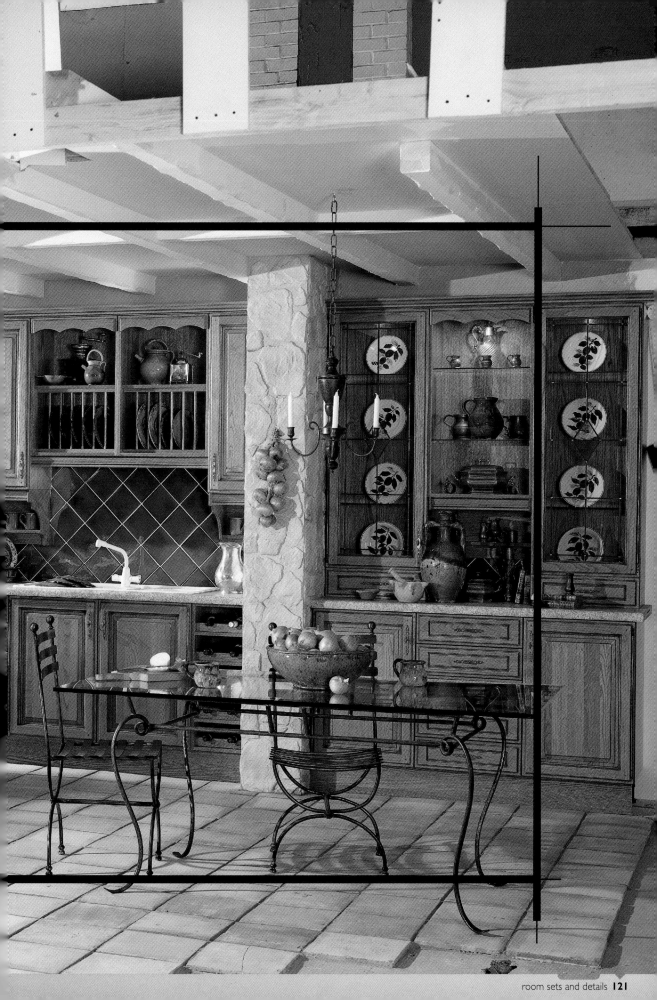

THE MARRIOTT KITCHEN

▼

THIS IS A CLASSIC EXAMPLE OF A BUILT SET WHICH, IN THE FORM IN WHICH IT WAS USED, LOOKS TOTALLY NATURAL — BUT WHICH WELL ILLUSTRATES THAT PHOTOGRAPHY IS TO A LARGE EXTENT THE ART OF ILLUSION.

It is also a classic example of the logic of 8x10 inch photography. When you have gone to the trouble and expense of building a set on this scale, it cries out to be photographed on the largest available format. The advantage of using tungsten lighting is then that you can always leave the shutter open for longer: this would require staggering power, or innumerable "pops", if it were to be photographed using flash. The key light, which creates the illusion of sun streaming in from a window to camera left, is a 1250-watt flood. Another 750-watt flood to the left of the clock creates the impression of light coming through a doorway. Two 500-watt floods on the far side of the window light a painted outdoor scene, overexposing it slightly in the interests of naturalism, and finally a 500-watt flood shines through a diffuser to camera right as a fill. Further fill is supplied by a large white bounce on the right hand side of the set.

Photographer: **David Watts ABIPP**
Client: **Crown Interiors**
Use: **Catalogue**
Art director: **Christopher Barclay**
Camera: **8x10 inch**
Lens: **300mm**
Film: **Fuji RTP 64 tungsten balance ISO 64**
Exposure: **28 seconds at f/45-1/2**
Lighting: **Tungsten: 5 heads, 3500 watts**
Props and set: **Built set; fitters and props from "Prop Company" London**

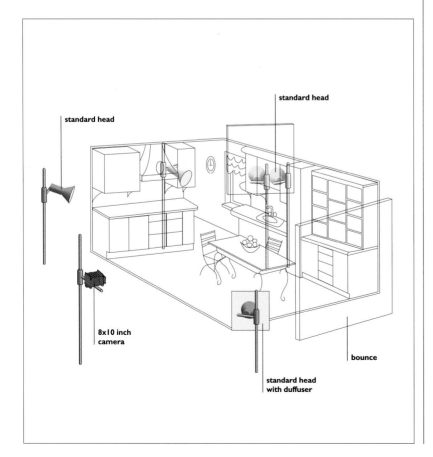

standard head

standard head

8x10 inch camera

bounce

standard head with duffuser

► *A total of 3500W is comparatively modest — car photographers commonly exceed 10,000W of tungsten lighting — but placement of lights is more important than sheer power*

► *Very large formats (8x10 inch and 11x14 inch) commonly require very small apertures in the interests of depth of field. Unless the lights can be brought very close to the subject, tungsten lighting with long exposures is often better than flash*

T R U F F L E H U N T E R S

▼

PHOTOGRAPHING THIS BAND OF TRUFFLE HUNTERS *AND THEIR DOGS* IN THIS ANCIENT DARK ROOM ON 4x5 INCH IS LITTLE SHORT OF HEROIC. THEN AGAIN, QUINTIN WRIGHT DID USE 4000W-S OF LIGHT TO DO IT — WHICH IS WHY THE LIGHT THROUGH THE DOOR IS BALANCED TOO.

Photographer: **Quintin Wright**

Client: **Personal; later used editorially**

Models: **Piedmontese truffle hunters**

Camera: **4x5 inch**

Lens: **90mm**

Film: **Fuji RDP ISO 100**

Exposure: **1/30 at f/16-1/2**

Lighting: **Electronic flash: 3 heads**

Props and set: **Location**

The main light on the figures is a 2400w-s soft box beside the camera, to camera right, which is quite adequate to illuminate the men and their dogs. Two further 800w-s units provide additional illumination in the "wings" of this L-shaped room. The one on the left is bounced down into an umbrella for a very broad, diffuse light and the one on the right is bounced up into the ceiling and onto the wall behind the right-hand figure. The overall result is an almost archetypal picture reminiscent of Rembrandt; if you look at *The Company of Captain Frans Banning Cocq and Lieutenant van Ruytenburg*, better known as *The Night Watch*, you will see that this too exhibits a surprisingly complex mixture of light sources which meld together into a seamless whole.

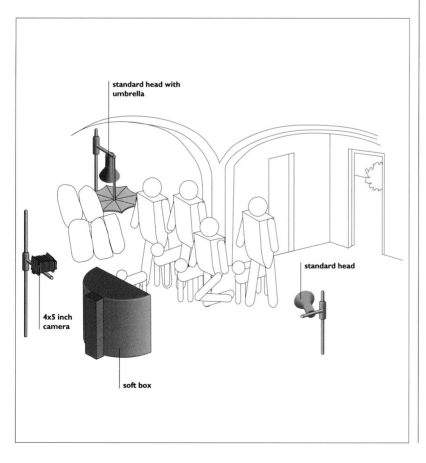

standard head with umbrella

4x5 inch camera

standard head

soft box

► If people have been asked to stand still, 1/30 second is generally a saf e speed to avoid subject movement; turn off the flash modelling lights to avoid secondary images

► Because most of the light on the subjects comes from the flash, movement during the remainder of the exposure should in any case be imperceptible

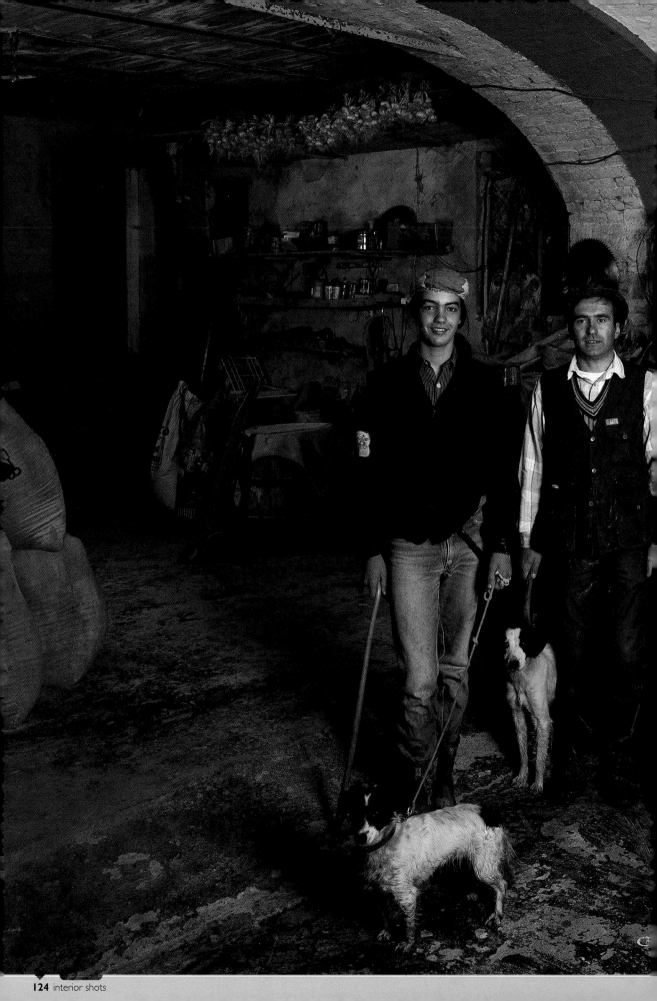

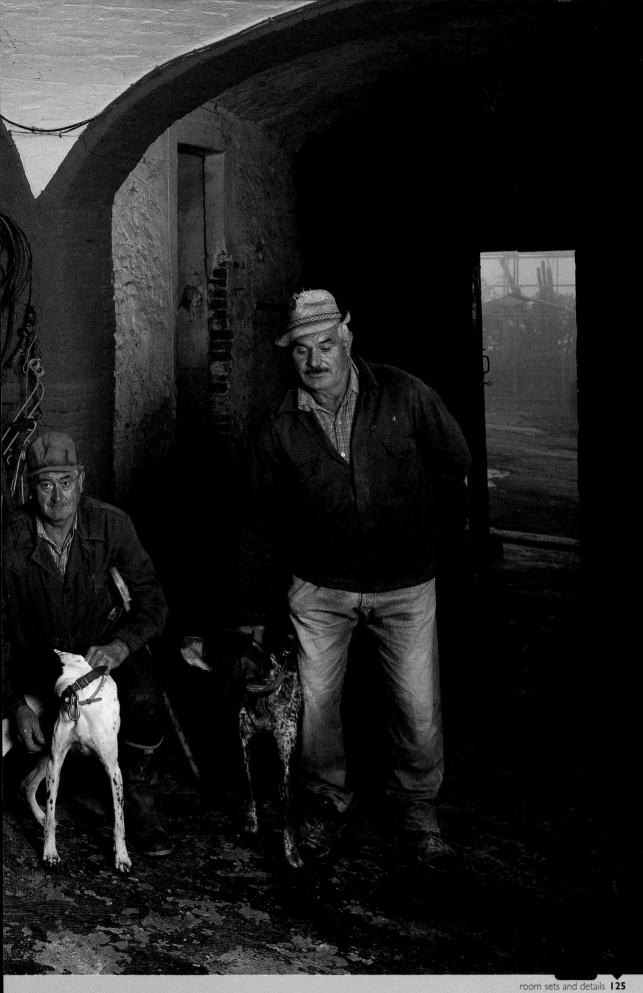

THE INFINITY ROOM

▼

Photographer: **Tim Hawkins**
Client: *Westside* **Magazine**
Use: **Editorial**
Camera: **4x5 inch**
Lens: **90mm**
Film: **Kodak Ektachrome EPP**
Exposure: **1/2 second at f/32**
Lighting: **Flash and daylight**
Props and set: **Location**

ANTHONY KOWALSKI IS AN ARTIST AND INTERIOR DESIGNER; HIS COMMENTS APPEAR IN PLACE OF THE NORMAL *PHOTOGRAPHER'S COMMENT* AT THE FOOT OF THIS PAGE. HIS REMARKABLE PAINTING IS HOWEVER MORE "REAL" IN THIS PHOTOGRAPH THAN IT CAN BE TO THE NAKED EYE.

The secret is substantially in the lighting. The camera is obviously looking into the corner of the room, and there are two lights: one to camera right, lighting the wall to camera left, and the other to camera right, lighting the wall to camera left. Both are very carefully shaded so that more light falls on the paintings at the edge of the composition, and less on the middle; the very top of the room, the upper corner where the room vanishes into infinity, is hardly lit at all. This greatly accentuates the illusion of the wall's disappearance, as even the best-applied paint still reflects some light. In the photographer's words, "What I needed was a midnight blue D max."

Lens and viewpoint were also important. The paintings are cropped so that they "fall into" the void, while a 90mm focal length stretched perspective just slightly for the same purpose.

standard head with flag

standard head with flag

4x5 inch camera

► *All paint reflects some light, and identical paint on surfaces at two different angles will "read" unless it is carefully lit*

► *Lens selection should be made wherever possible on the basis of the perspective that is required*

Artist's comment:

Enter a virtual world where time and sense of place are suspended; an orchestrated dance between the ancients, a corrupted reproduction of the past and an antiqued version of possible futures, an encapsulation of time in all its fluidity.

M A T S U S H I T A C A T A L O G U E

Photographer: **Kenichi Ura**

Client: **Matsushita electronic works**

Use: **Catalogue**

Art director: **Toshihiko Inagaki**

Stylist: **Mitsuru Ikenaga**

Camera: **4x5 inch**

Lens: **135mm**

Film: **Kodak Ektachrome 64T**

Exposure: **4 seconds at f/16**

Lighting: **Tungsten: 10 lights**

Props and set: **Built set/Matsushita goods**

▼

It almost defies belief that this is a room set, so elaborate is it. Then you discover that it was lit with ten lights: elaboration piled upon elaboration. There are two 5K spots, three 3K spots, and five 1K spots.

The two most powerful lights illuminate the middle window and the right hand side as if from a window. The one on the left creates the "sun", while the one on the right is diffused through tracing paper, with a flag to keep spill off the ceiling. The 3K lights again illuminate the three windows of the set, only two of which appear in the picture: all three are diffused to create directionless "sky light." Four more lights are bounced, again for a diffuse light, while one (again diffused through tracing paper) adds some more light from camera left.

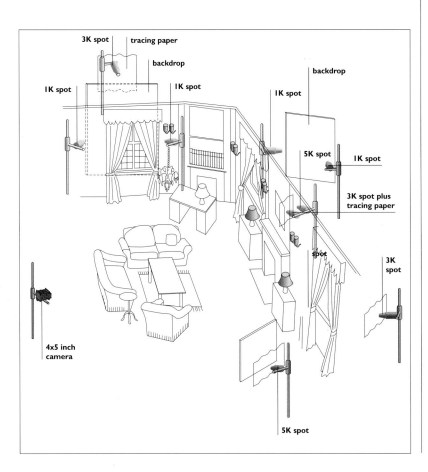

► Of the 24K of light used, only a fraction illuminates the interior of the set – but the effect is extremely natural

► Large sheets of tracing paper make excellent diffusers and good reflectors

► NECO (New Enlarging Color Operation) backgrounds provide the "exterior"

Photographer's comment:

Leisure class, life's pleasure. The important thing was to make the lighting look natural in a specially-built set.

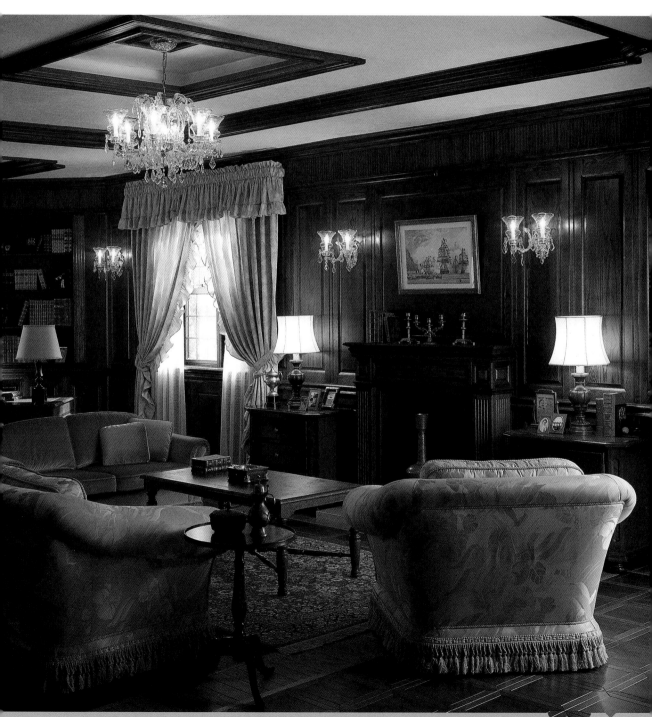

YAMAHA PIANO
SILENT SERIES

Photographer: **Kenichi Ura**

Client: **Yamaha Co.**

Use: **Poster**

Art director: **Hideo Kasahara (C.'s Co.)**

Camera: **4x5 inch**

Lens: **180mm with 81EF warming filter**

Film: **Kodak Ektachrome EPN**

Exposure: **4 sec. at f/16**

Lighting: **Flash plus available (tungsten) light**

Props and set: **Location**

▼

THE WARMTH OF THE TUNGSTEN LIGHTS IN SHOT IS OBVIOUS, AND AT FIRST IT SEEMS THAT THIS MAY BE LIT ENTIRELY WITH TUNGSTEN BUT SHOT ON DAYLIGHT FILM. CLOSER INSPECTION REVEALS THAT THE WHITE HIGHLIGHTS (KEYBOARD AND MUSIC) ARE WARM BUT NOT YELLOW.

This unusual effect is obtained by lighting the piano itself with two (2400w-s) flash units, and warming the whole scene with an 81EF filter across the lens. A long exposure – 4 seconds – then records the tungsten lights in shot, almost to the point of burning them in.

The key light is a standard head to camera left, diffused through a large sheet of tracing paper, while the subsidiary light is a spot which is carefully flagged to illuminate only the interior of the piano which would otherwise be a black hole.

The filtration has proportionately more visual effect on the flash than on the tungsten light. It shifts the flash from cool daylight to warm daylight (about 5800-6000°K to about 4500-5000°K) while leaving the tungsten a warm yellow which is however ameliorated by generous exposure.

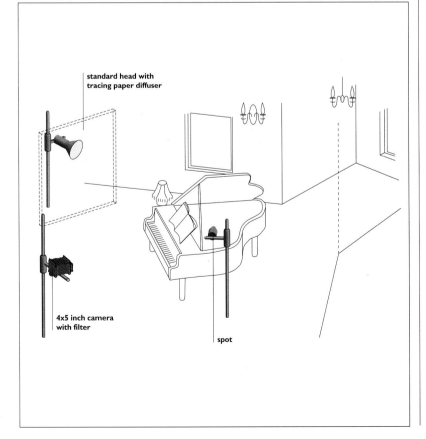

standard head with
tracing paper diffuser

4x5 inch camera
with filter

spot

▶ *The higher the colour temperature of a light source (the more blue it is), the more effect an 81-series filter will seem to have*

▶ *Underexposing a light with a low colour temperature (a "warm" light) will make it seem more yellow: overexposing it will make it seem less yellow*

Photographer's comment:

I wanted to express the pleasure of playing music with the piano.

COLOURED CONES IN A WHITE ROOM

▼

Photographer: **Lu Jeffery**
Client: *Homes & Gardens*
Use: **Editorial**
Assistant: **Richard Thoday**
Stylist: **Kate Hardy**
Camera: **6x6cm**
Lens: **80mm**
Film: **Fuji RDP ISO 100**
Exposure: **1 sec f/16**
Lighting: **Electronic flash: 1 head plus daylight**
Props and set: **Stylist "edited" props from house**

THE WHITENESS OF THIS ROOM IS DELIGHTFULLY REFRESHING; IT FEELS LIGHT AND AIRY AND SUNNY. THE PROBLEM IS THAT IT IS ALSO WELL SUPPLIED WITH REFLECTIVE SURFACES: THE MIRROR, THE TABLE, THE GLASS OVER THE PICTURE.

Another problem is the black wood of the cupboard – wonderfully dramatic, but difficult to hold in the context of an essentially high-key picture.

The daylight through the window is the obvious key to the lighting, but as so often in modern houses this was insufficient on its own, the more so given the white-on-white decor. Lu Jeffery therefore supplemented it with a single electronic flash head with a small standard "spill kill" reflector on a tall stand where it could bounce off the (white) ceiling and add a diffused light to the interior of the room. Look at the plant on its stand at the right-hand side of the picture: without this supplementary lighting, the white-on-white effect would be lost and the chiaroscuro of the windowlight would create quite a different effect. Finally a small bounce, low down to camera right, added definition and interest to the black of the cupboard.

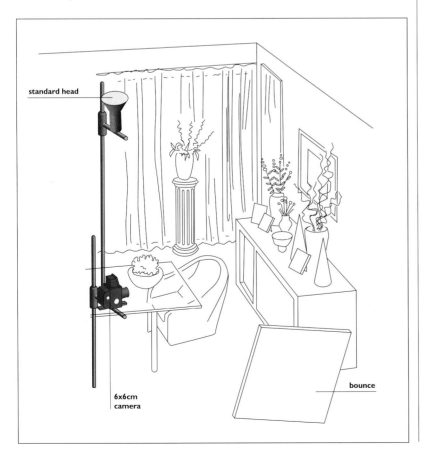

standard head

6x6cm camera

bounce

► *Indirect, diffuse lighting is normally essential for a high-key effect*

► *Modern houses normally have lower ceilings than older ones which means that you need less power when bouncing light off the ceiling*

► *Even black surfaces normally have some reflectivity and a small bounce can stop them being dull and flat*

FLYING BOARDS

▼

THE SET WAS BUILT THREE-DIMENSIONALLY INTO THE PAINTING, WHICH VARIED ACROSS A SEQUENCE OF SHOTS, STARTING WITH A FULL PAINTING AND AN EMPTY ROOM AND ENDING WITH AN ALMOST EMPTY PAINTING AND A FULL ROOM: THE OBJECTS "MIGRATED" FROM THE PAINTING.

Photographer: **Jay Myrdal**

Client: **A.M.C. for Pioneer Int.**

Use: **Catalogue**

Assistant: **Dave Chalmers**

Art director: **Martin Neagus**

Painter: **Gordon Aldred**

Camera: **8x10 inch**

Lens: **155mm and CC10Y**

Film: **Kodak Ektachrome EPP**

Exposure: **f/45**

Lighting: **Flash**

Props and set: **Built set; props hired or built**

A soft box over the top provided fill, but the key is effectively the powerful spot from camera right which illuminates the painting; a further couple of spots, with a shadow board, provided the lighting on the back of the room. The window is a cutout, lit by diffuse light bounced off a polyboard "cove" built behind it; different coloured gels were used in the window for the different shots. The "flying" boards were suspended with many thin pieces of fishing line, which are less obtrusive than fewer, thicker pieces, and although the principal illumination was flash, the shutter had to be dragged somewhat in order to record the tungsten lights which are in shot. When the hi-fi was in shot, long exposures were needed to record the illuminated instrument panels; the other lights were turned off for these exposures.

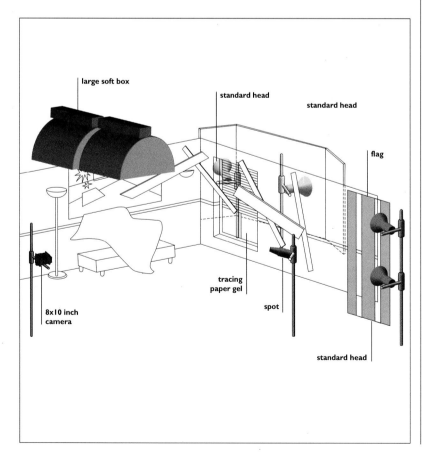

large soft box

standard head

standard head

flag

tracing paper gel

spot

8x10 inch camera

standard head

► Photographers specializing in complex, conceptual pictures like this will need an extensive array of contacts among model makers, painters, prop finders and the like

► Even when no subsequent image manipulation is required, an 8x10 inch original gives a richer, more detailed picture

Photographer's comment:

This was a personal version of a catalogue for Pioneer Europe; we removed the product (hi-fi) from the foreground and shot this for the portfolio.

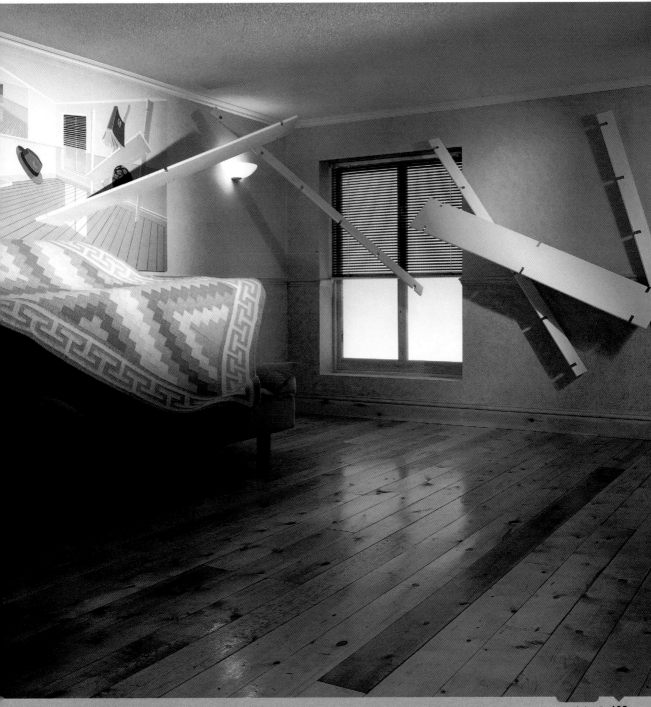

BEAUTY PARLOUR

▼

Photographer: **Quintin Wright**

Client: *Ellesential*

Use: **PR for interior designer**

Camera: **4x5 inch**

Lens: **121mm**

Film: **Fuji RDP ISO 100**

Exposure: **1 second at f/32-1/2**

Lighting: **Electronic flash: 1 head plus 2 tungsten heads, gelled to daylight**

Props and set: **Location**

ALTHOUGH MIRRORS STRIKE TERROR INTO THE HEART OF MANY, THEY ARE NOT IMPOSSIBLE TO LIGHT IF YOU APPROACH THE SHOT METHODICALLY AND WITH ENOUGH LIGHTING RESOURCES – THOUGH NORMALLY, THE LIGHTING IN THE AREA REFLECTED BY THE MIRROR MUST BE WELL DIFFUSED.

The stairway reflected in the mirror here is a considerable distance away and it is lit by two "Redhead" 800-watt tungsten lights gelled to daylight balance. An interesting aside is that the photographer prefers gels to dichroics, of which "I have two in my case but I have never used them." His view is that gels give a softer and more natural light – and certainly, one can buy a lot of gels for the price of a single dichroic filter.

The principal light is a 2400w-s flash head in a soft box to camera left, mounted "seven or eight feet" high; about 2.1 to 2.4 metres. The very warm yellow of the walls is what creates the impression of warm tungsten lighting. The swings of the 4x5 inch camera were used in conjunction with careful camera placement to get an interesting image in the mirror.

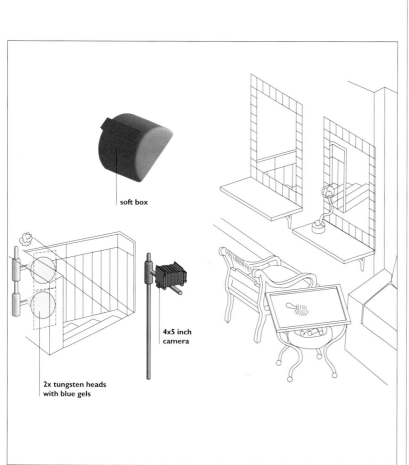

soft box

4x5 inch camera

2x tungsten heads with blue gels

► *Blue gels (actually acetate) provide an easy and economical way to bring tungsten lighting to daylight balance*

► *Depth of field can be a problem with mirror shots, so small apertures are normally called for*

► *With a cross front, you can even photograph a mirror apparently square-on without having the camera in shot*

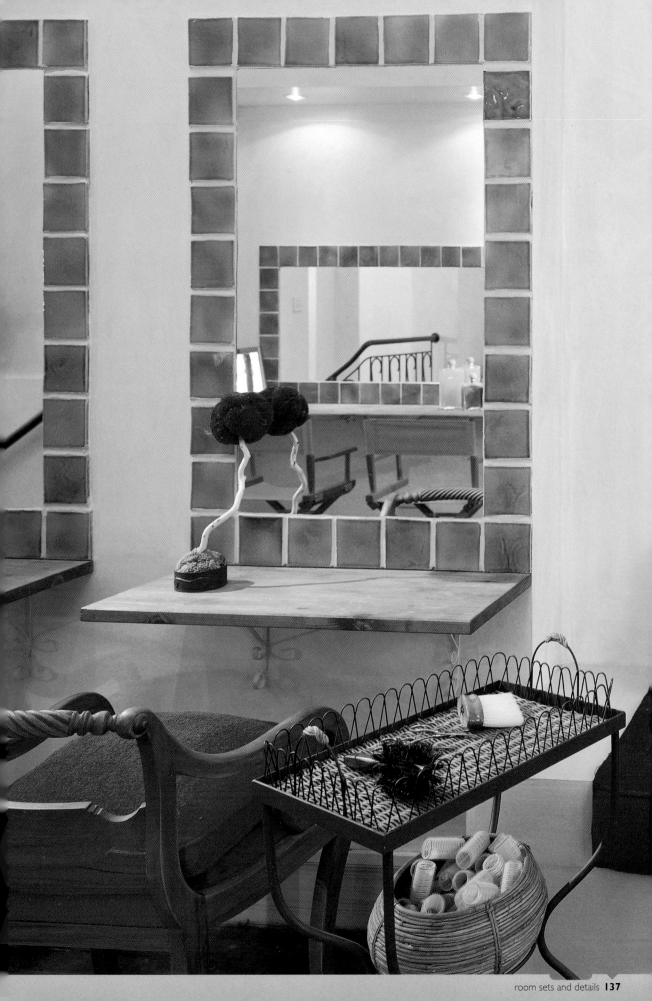

7

a window on the
world

In this last chapter, the emphasis is on pictures which deal with an abiding problem: the relationship between indoors and outdoors. The most obvious question is what happens when a window is included in a picture. All too often, as every photographer knows from his or her earliest experiments, the choice is between a correctly-exposed exterior framed by the window, but accompanied by a grievously underexposed interior, or a correctly exposed interior which is however marred by a view through the window which is burnt out almost to invisibility. A third unhappy possibility is overlighting the interior, so that even in full day the exterior looks like night – and all of these disasters ignore the additional risks of lights reflecting in windows.

In this chapter, there are several different ways of addressing the problem, but the one with the greatest appeal of simplicity comes from Quintin Wright: you wait until the light outside the window is of the right intensity to balance with the lighting that is available. Like many simple pieces of advice, it is incontrovertible but can be more difficult to follow than it seems. Quintin also makes the intriguing (and not immediately obvious) point that often, a blue sky with fluffy white clouds is better than a pure "Chamber of Commerce" blue sky. David Watts shows just how much illumination is needed to balance the light coming through a stained-glass window (and throws in candles as well, as a sort of tour de force), while the sepia Polaroid of a centuries-old covered passageway in Forcalquier shows that there are other solutions than the obvious ones.

THE CORONA, CANTERBURY CATHEDRAL

▼

Stained glass is a perennially fascinating subject, and one which most photographers try shortly after getting their first "serious" camera. It remains however a perennially difficult subject, and proper lighting is the only way to approach it.

Photographer: **David Watts ABIPP**

Client: **Cathedral Gifts**

Use: **Cathedral guide, view cards, posters**

Assistant: **Howard Thundow**

Camera: **4x5 inch**

Lens: **150mm**

Film: **Fujichrome Provia ISO 100**

Exposure: **1 second at f/22**

Lighting: **Flash plus available light**

Props and set: **Location**

In this case, life was made still more interesting by the candles, though fortunately a slight underexposure of the flames emphasizes their yellowness and diminishes their brightness, which might otherwise have detracted from the majesty of the window.

The main determinant of exposure is clearly the light through the stained-glass. A fair amount of rising front was needed, for obvious reasons, and an exposure of 1 second at f/22 gave the most convenient combination of shutter speed and aperture. The supplementary lighting – three soft boxes, was chosen to complement the f/22 working aperture.

The lighting itself is symmetrical. On either side of the window are 6000w-s soft boxes on stands nine feet above the floor, while directly above the camera is another 6000w-s unit aimed at the upper part of the arches.

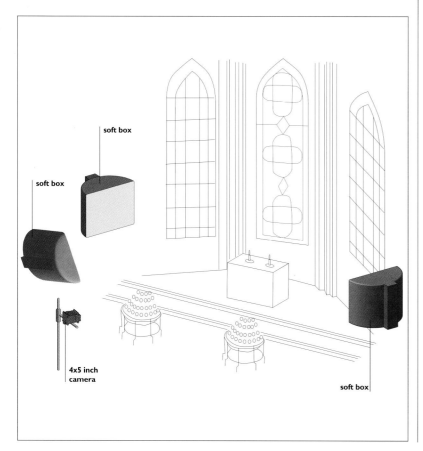

soft box

soft box

4x5 inch
camera

soft box

► *Cathedral interiors are proverbially cavernous and hard to light: enormous quantities of power may be needed*

► *Tall, strong lighting stands are essential; otherwise, you need tall, strong assistants to stabilize them*

► *When faced with two important light sources in shot (the window and the candles) you have to decide which determines the exposure*

OFFICE

▼

Photographer: **Quintin Wright**

Client: **Property**

Use: **Brochure**

Camera: **4x5 "pancake" with 6x9cm back**

Lens: **75mm**

Film: **Fuji RDP ISO 100**

Exposure: **1/60 second at f/11**

Lighting: **Electronic flash: one head plus ambient**

Props and set: **Location**

BALANCING AN EXTERIOR SCENE AND INTERIOR LIGHTING CAN BE VERY DIFFICULT INDEED, BUT ONE WAY TO IMPROVE THE ODDS IN YOUR FAVOUR IS TO WAIT UNTIL THE EVENING WHEN OUTSIDE LIGHT LEVELS FALL AND LESS POWER IS REQUIRED TO BALANCE AMBIENT LIGHT.

Also, evening light is more diffuse than light earlier in the day, which again makes things easier. This was taken at about seven on a summer's evening, when the light intensity outside had fallen but the lighting was still unquestionably sunlight. Then, all that was needed was a single, reasonably powerful soft box (a 650 watt-second unit was used) to camera left, almost resting on the table in front of the businessman and also to his left. Look at the shadows of the items on the table and you can see that the light was fairly high; look at the shadow of the businessman's chair and you can see that it was not that high.

The angle of the soft box also had to be carefully chosen to avoid reflections. If it had been too far to camera left it would have flashed back from the windows; any further right, and it would have looked like on-camera flash.

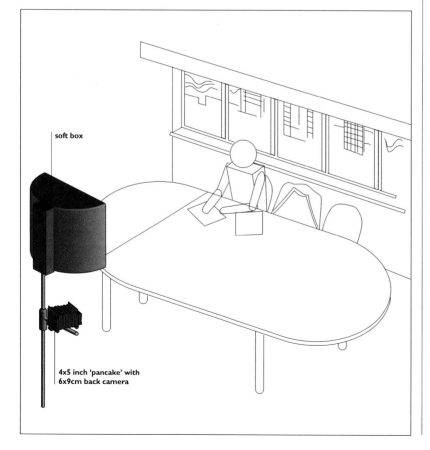

soft box

4x5 inch 'pancake' with 6x9cm back camera

► *Waiting until evening can make it easier to balance inside and outside lighting*

► *"Pancake" cameras such as the Silvestri (used here) and the Cambo Wide are designed for use with wide-angle lenses and are normally used with roll-film backs (where movements are generous) rather than with 4x5 inch*

Photographer's comment:

I had only the one head with me, and I would not have minded another; I was faced with the choice of this style of lighting, or bouncing it off the walls, but I think I made the right choice.

GARDEN ROOM

▼

IN ALL PROBABILITY, ONLY ANOTHER PHOTOGRAPHER WOULD REALIZE THAT THERE WAS ANY ADDITIONAL LIGHTING IN THIS PICTURE. THE OVERALL EFFECT IS SO NATURAL, AND SO CLOSE TO THE WAY WE THINK WE SEE, THAT IT SEEMS TO RELY ONLY ON NATURAL LIGHT.

This is of course as it should be. Daylight from the windows and the enormous glass roof provide the key, and all other lighting is subordinate to this. The only real clue is the timber screen or guardrail on the right, which is a little lighter than it could naturally be – but any darker would be too dark.

A soft box almost over the camera (actually, slightly to the right) fills the foreground including the aforementioned screen, and two bounce umbrellas on the extreme left (out of shot) and the extreme right (concealed by the wall) add a mood of lightness and airiness and lighten the drapes.

The really difficult part in a shot like this lies in stopping any of the additional lighting from reflecting in the glass, either directly or (which is harder to spot) indirectly off a polished table top or something similar.

Photographer: **Harry Lomax**

Client: **Portwall Design**

Use: **Editorial**

Camera: **6x6cm**

Lens: **40mm**

Film: **Fuji RDP ISO 100**

Exposure: **1/60 at f/11**

Lighting: **Electronic flash: 3 heads plus ambient**

Props and set: **Location**

standard head with umbrella

standard head with umbrella

soft box

6x6cm camera

► *Even after you have set up everything as carefully as possible, a Polaroid test is the easiest way to spot unwanted reflections*

► *Greenery (like the ferns in the foreground) often looks best with a little extra lighting*

Photographer's comment:

The additional lighting was simply to raise the overall light levels enough to show the exterior as well as the interior design. The problem was the large area of reflective glass.

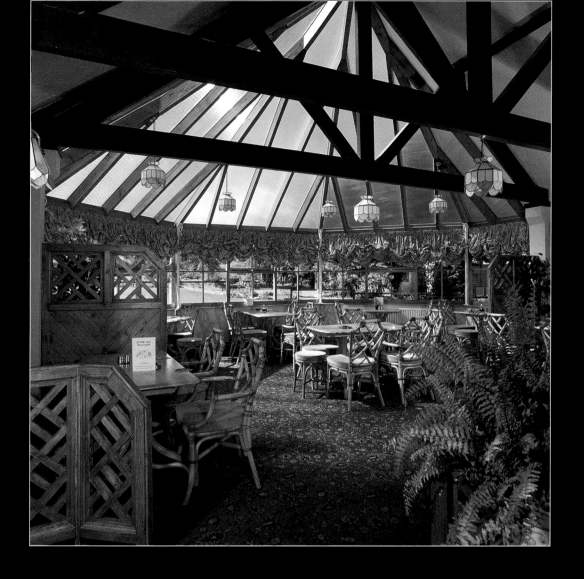

CONSERVATORY

Photographer: **Quintin Wright**

Client: **Frost & Co.**

Use: **PR**

Camera: **4x5 inch**

Lens: **90mm**

Film: **Fuji RDP ISO 100**

Exposure: **1/8 second at f/22**

Lighting: **Electronic flash: 1 head plus ambient**

Props and set: **Location**

▼

A SOPHISTICATED FLASH METER, AND PLENTY OF EXPERIENCE IN USING IT, IS ESSENTIAL IF YOU WANT TO USE FILL AS SUBTLY AS THIS. THE KEY IS CLEARLY THE AMBIENT LIGHT; AND YET THERE ARE 2400 WATT-SECONDS OF FILL FLASH IN THIS PICTURE.

Even with a 90mm lens, the depth of field requirements in this shot were such that f/22 was essential. Matching the requisite shutter speed to this was simple: 1/8 second gave the rich, saturated colours which are an essential part of the picture, together with the clearly directional lighting – look at the patterns of light on the sofa and on the floor to the right. Ambient light alone would however have left the lower right-hand side of the picture very dark indeed, and the pattern of the material on the near side of the table would have been illegible: dark fabrics "eat" light. A 2400w-s soft box to camera right was two to three stops below ambient lighting (and therefore did not spoil the shadows under the table or the light patterns on the floor) but still provided enough fill to reveal detail as needed.

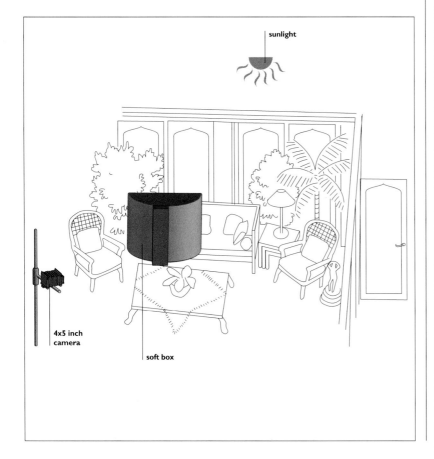

► Even 2 stops down can be too powerful for a fill – and even 5 stops down can make a difference

► Colour balance in a scene with plenty of green is not usually too critical, compared with neutral greys and whites

► A 90mm lens provides appreciably more even illumination across the image area than a wider lens

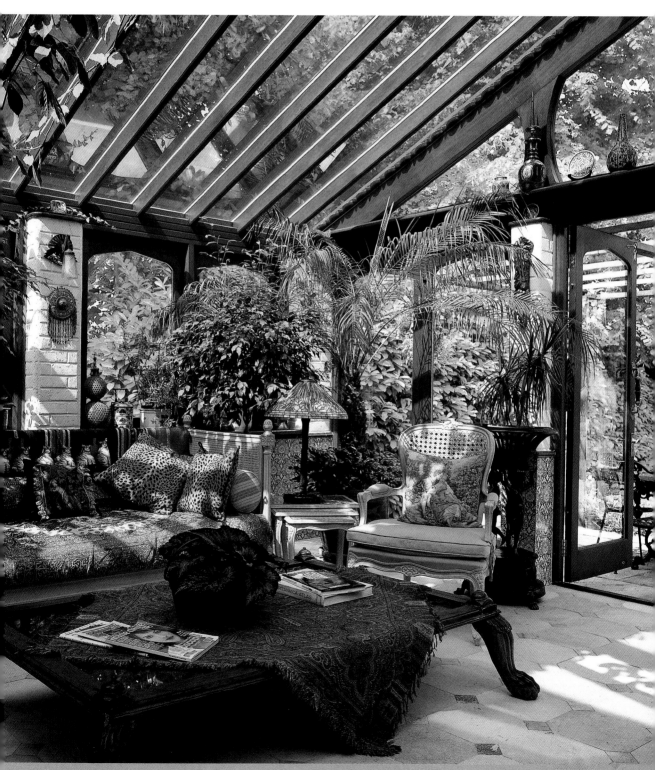

CONSERVATORY/ DINING ROOM

▼

THE SECRET TO INSIDE/OUTSIDE SHOTS LIKE THIS IS NORMALLY A LOT OF LIGHT.
THE BASE EXPOSURE IS CHOSEN TO SUIT THE OUTSIDE LIGHT, AND THEN PLENTY OF
FLASH IS BROUGHT IN TO BALANCE IT — IN THIS CASE, 4800W-S SPLIT
BETWEEN TWO SOFT BOXES.

Photographer: **Quintin Wright**

Client: **Frost & Co.**

Use: **PR**

Camera: **4x5 inch**

Lens: **75mm**

Film: **Fuji RDP ISO 100**

Exposure: **1/4 second at f/22**

Lighting: **Electronic flash: 2 heads plus ambient**

Props and set: **Location**

Once you have the power on tap (and the experience) the lighting is relatively simple. One 2400w-s unit was pushed through a soft box to camera right, providing the fill in the right foreground and creating the tell-tale highlight on the enamelled stove on the far right, while the other 2400w-s went through another soft box placed very high up on the left and shining down on the table. The distortion of the chairs gives this away as

an extreme wide-angle shot, taken with a 75mm lens on 4x5 inch film; the equivalent, very roughly, of 40mm on 6x6cm or 21mm on 35mm.

The perspective is however modified by the use of camera movements; although the front standard was almost square-on to the far wall, the rear standard was swung in the interests of depth of field and exaggerated shapes to the left of the photograph.

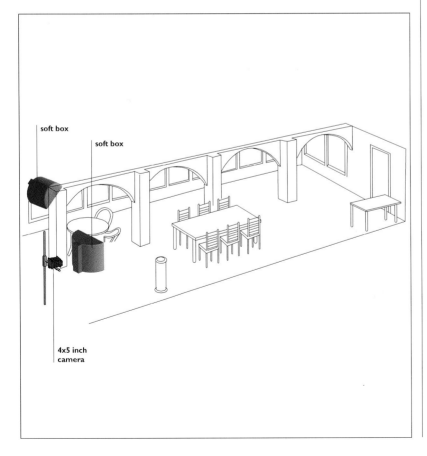

► *You can never have too much power; it is a lot easier to turn down the power of a large unit than to do multiple "pops" with a lower-powered unit*

► *"Press" (self-cocking) shutters do however give the option of multiple "pops" without the risk of moving the camera while re-cocking the shutter. Two 1/8 second exposures at f/22 with a 1200w-s unit equate to 1/4 second with a 2400w-s unit*

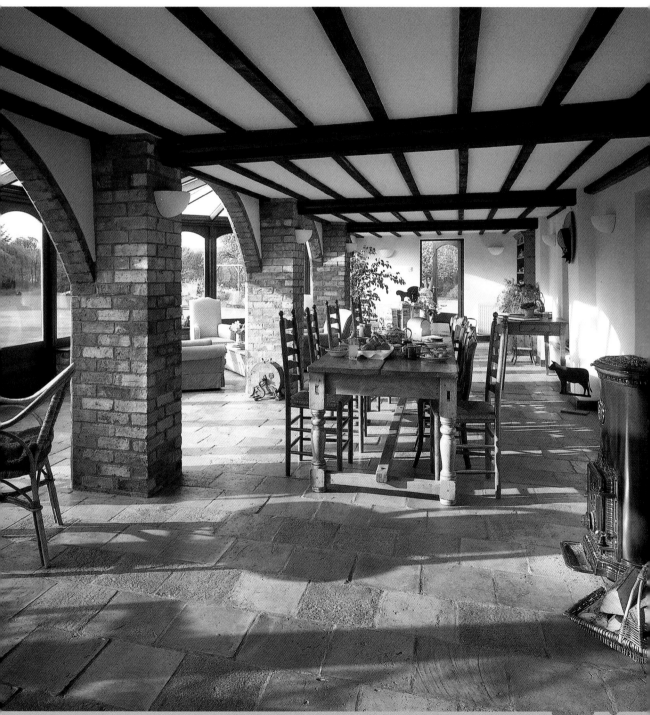

COULOIR, FORCALQUIER

▼

Enormous contrast ranges are a common problem with "inside/ outside" pictures, and one way to tame them is with low-contrast monochrome films — either overexposing and underdeveloping conventional films, or choosing low-contrast materials like Polaroid Sepia.

Photographer: **Roger W. Hicks**

Client: **Personal work**

Use: **Book proposal and magazine editorial**

Camera: **4x5 inch**

Lens: **120mm**

Film: **Polaroid Sepia**

Exposure: **10 seconds at f/22**

Lighting: **Available light**

Props and set: **Location**

The outside light was brilliant Provengal sunlight at around noon, while the interior was not highly reflective. The lens was well stopped down for depth of field, which necessitated the long exposure; Polaroid sepia material is rated at ISO 200. The overall range of detail is remarkable, while the sepia film also has the advantage of subordinating relatively modern and unattractive aspects of the scene to the overall mood of unspecified nostalgia: the steps to the left, for example, are of relatively modern concrete and are unpleasantly obvious and grey in a colour picture. In conventional monochrome they are less obtrusive, but in sepia they are less obtrusive still.

Origination from most Polaroid 4x5 inch materials is feasible: their resolution is generally 20-25 line pairs per millimetre, which allows at least a 2.5x enlargement (A4 full page) while retaining critical sharpness.

4x5 inch camera

► *Monochrome films can hold a wider tonal range than colour films*

► *Using Polaroids as originals instead of just for tests allows the photographer to know that the shot is "in the can" before leaving the shoot*

Photographer's comment:

The principal purpose of this image was for a proposal for a series of travel guides with an historical slant, but it was also used editorially in the photographic press.

POOL

▼

Photographer: **Quintin Wright**

Client: **Architect**

Use: **Record**

Camera: **4x5 inch**

Lens: **65mm**

Film: **Fuji RDP ISO 100**

Exposure: **1/30 second at f/22**

Lighting: **Ambient**

Props and set: **Location**

Although this shot uses absolutely no supplementary lighting, nor yet any reflectors, it still has an important lesson for the photographer of pools, patios etc and for the photographer of exteriors. It is that a clear blue sky is not necessarily what you want.

A white sky would clearly have been inappropriate, but surprisingly, so was a clear blue sky. The extensive white clouds were essential to the shot. With a clear blue sky, there was not enough diffused light reflected back from the pool to show up the white ribs which support the pool cover: they were too dark, and the lightness and airiness of the covered area was lost entirely. What is more, the dark undersides of the supporting ribs sat ill with the white reflections of their upper sides. This was shot at about three in the afternoon in high summer – August – and the light is in the classic "snapshot" location, over the photographer's right shoulder. It is also worth noting that the distortion introduced by a 65mm lens is imperceptible because of the lack of clues in the image; the island or fountain to the right is actually round, but there is no evidence of this in the picture, so we accept it for the shape it is.

► If you are forced to rely on ambient light, the only practical approach is to wait until it comes right

► Blue sky with partial white cloud cover diffused the light to the extent that was necessary for the shot

► Direct sunlight from over the photographer's shoulder created the clear shadows and the patterns of light and shade on the water which are essential for the shot

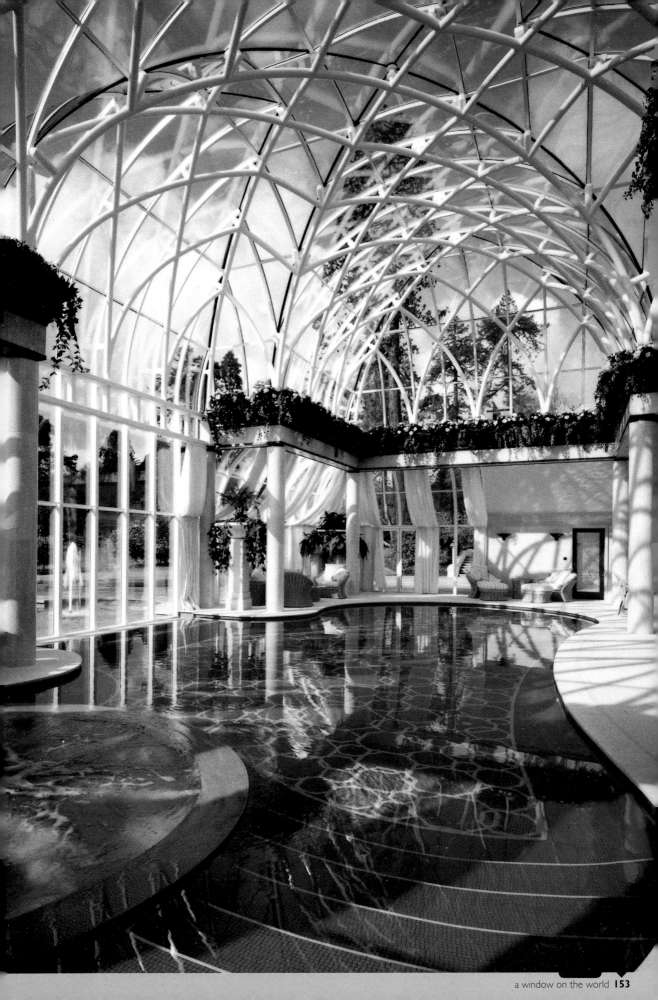

8

directory of photographers

Photographer: **FRANCESCO BELLESIA**

Studio: WANTED

Address: VIA PEROSI 5

20146 MILANO

ITALY

Telephone: + 39 (2) 48 95 26 50

Fax: + 39 (2) 42 34 898

Biography: *La mia attività di fotografo dura ormai da circa 20 anni nei quali ho affrontato le più svariate sitiazioni muovendomi in diverse specializzazione – oggi la company di cui faccio paret opera con sistemi avanzati sia in fase di ripresa (digitale) che in post produzione.*

Indoor shot: Alma Ticinensis Universitas p93

Photographer: **ROBIN CHANDA**

Address: FLAT 6, 37 BROMLEY ROAD

BECKENHAM

KENT BR3 2NT

ENGLAND

Telephone: + 44 (1 81) 658 5933

Fax: + 44 (9 74) 337 834

Biography: *Trained as an architect, Robin has been a freelance photographer since 1991. His architectural training not only allows him to understand light, mass and function with an architect's eye: it also greatly simplifies briefings because he can read plans and can therefore visualize the most promising approaches to photographing a building whether inside or out. His photography is not limited to architectural work; as well as leading architects, clients include Channel 4 and Saga.*

Indoor shot: Restaurant p85

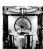

Photographer: **MICHEL DE MEYER & MAX SCHNEIDER**

Address: VINKENDAM 6

B-9120 BEVEREN

BELGIUM

Telephone: + 32 (3) 775 47 64 AND 755 34 74

Fax: + 32 (3) 755 30 15

Biography: *They are two photographers who have joined their efforts to maximize the efficiency of their technical*

infrastructure. They do about one-third publicity, one-third editorial and one-third packaging. They also work for The Image Bank.

Indoor shots: Tea in the Drawing Room p27, Dining Room p61

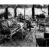 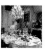

Photographer: **TIM EDWARDS**

Address: PLOUGH STUDIOS

9 PARK HILL

LONDON SW4 9WS

ENGLAND

Telephone: + 44 (1 71) 585 2001

Fax: + 44 (1 71) 627 5169

Biography: *Trained in room-set studios in North Carolina, USA. Now based in London, shooting architecture and interiors for commercial agents and architects/ interior designers.*

Indoor shots: Sun Lounge p31, Study p33, Lobby with Sunburst Table p95, Pastel Lobby p111, Arched Door p113, Formal Staircase p117

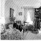 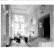

Photographer: **THOMAS GEORGE EPPERSON**

Studio: T.G.E. PHOTOGRAPHY

Address: 4898 DURBAN STREET

MAKATI METRO MANILA

PHILIPPINES

Telephone: + 63 (2) 141 242 322

Fax: + 63 (918) 870 2887

Biography: *Never having had any formal training, his knowledge came through reading and working as a freelance assistant in Australia for 3 years. Freelancing gave him the opportunity to study a variety of lighting techniques. Working in the Philippines it is very difficult to specialize: one must be able to do a wide variety of work, well and quickly. He is probably most known for corporate work but*

clients include Philippine Airlines, San Miguel, Nike, Shangri La Hotel, Peninsula Hotel, Shell, Saniwares, Purefoods, Tupperware, Wise and Co, P.N.O.C. and I.C.I.S.I.

Indoor shot: Bathroom, Presidential Suite p37

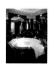

Photographer: **MICHÈLE FRANCKEN**

Studio: C.P.M. FRANCKEN

Address: VLAANDERENSTRAAT 54

9000 GENT

BELGIUM

Telephone: + 32 (9) 225 43 08

Fax: + 32 (9) 224 21 32

Biography: *Créer une ambiance avec la lumière et la composition. Travaillant beaucoup en location pour trouver plus d'intimité. Me sentant à l'aise aussi bien en mode qu'en publicité. Cherchant le moyen technique d'émouvoir le spectateur!*

Indoor shot: Libeco Brochure p59

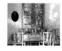

Photographer: **ROY GENGGAM**

Studio: GENGGAM PHOTOGRAPHY

Address: JL. KH. MUHASYIM VIII NO. 37

CILANDAK-JAKARTA

INDONESIA

Telephone: + 62 (21) 76 93 697

Fax: + 62 (21) 75 09 636

Biography: *Photographer with cinematography education, specializing in advertising and architectural photography, and also much work in fine art photography.*

Indoor shots: Full Colour p19, Chequers p75

 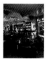

Photographer: **TIM HAWKINS**

Address: 35 NANSEN ROAD

LONDON SW11 5NS

ENGLAND

Telephone: + 44 (1 71) 223 9094

Fax: + 44 (1 71) 924 2972

Mobile Phone: + 44 (8 36) 586 999

Biography: Ante Photography: *digger driver, Fleet Air Arm helicopter pilot, J. Walter Thompson and more. First photographic commission: lady holding cup of tea, Uxbridge 1981, fee £22.50 including materials. Worst moment: arriving on location with no lens for 4x5 inch camera. Training: "Uncle" Colin (Glanfield), Plough Studios, London. Good at: orange segments to Landscape Arch and Interiors. Work/work: Glaxo, Philips, Observer, TSB, Royal Navy, Independent, Lancome, Price Waterhouse, Trafalgar House, P&O . . . Work/play: books – Photographers' Britain Dorset (1991). WWII American Uniforms (1993). Best purchase: Linhof Technikardan. Favourite camera: Leica M2 + 21mm. Photographers that come to mind: Strand, Coburn, Brandt, Brassai, George Rogers, Capa, Larry Burrows, Tim Page. Outlook: CC20R+CC05M.*

Indoor shots: Bedroom with Lily p42/43, Kitchen p57, The Infinity Room p127

Photographer: **ROGER W. HICKS**

Studio: ROGER & FRANCES

Address: 5 ALFRED ROAD
BIRCHINGTON
KENT CT7 9ND
ENGLAND

Telephone: + 44 (1 843) 848 664

Fax: + 44 (1 843) 848 665

Mobile Phone: + 44 (3 74) 952 698

Biography: *Cornish photographer and writer based in Kent but working in Britain and the United States as well as shooting travel for stock and magazine articles. Particularly fond of historic buildings and interiors. Author of over 50 books including this one. Works with his American-born wife, Frances E. Schultz, also a writer and photographer. Actively seeking writing/photography commissions, whether magazine*

articles, books, or publicity/PR work.

Indoor shots: Sturdivant House p29, Couloir Forcalquier p151

Photographer: **NEIL HUDSON**

Address: THE OLD CHAPEL
WESTFIELD ROAD
LEEDS LS3 1NQ
ENGLAND

Telephone: + 44 (1 13) 244 9050

Fax: + 44 (1 13) 244 9060

Biography: *Originally trained in Graphic Arts, Neil Hudson moved into photography in the early 1970s. Since the mid-1980s he has specialized in creating quality room-set and interior images for high-profile branded clients.*

Indoor shot: Bathroom p53

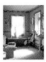

Photographer: **LU JEFFERY**

Address: PROVIDENCE MILL
GORSEY BANK
WIRKSWORTH
DERBYSHIRE DE4 4AD
ENGLAND

Telephone: + 44 (1 62) 982 5222

Fax: +44 (1 62) 982 5022

Biography: *Lu Jeffery is a freelance photographer specializing in interiors, gardens and animals. Her work appears regularly in around thirty different magazines and she is currently working with book publishers. She is actively seeking advertising commissions in her photographic specializations. Lu has been a member of The Association of Photographers for many years.*

Indoor shots: Classical Bathroom p51, Jennifer Aldridge in her Kitchen p65, Babington House p67, Chiaroscuro Hole in Wall p69, Coloured Cones in a White Room p133

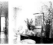

Photographer: **HARRY LOMAX**

Address: ROWDECROFT
ROWDE
DEVIZES
WILTS SN10 1SN
ENGLAND

Telephone: + 44 (1 380) 828 907

Fax: + 44 (1 380) 828 507

Mobile Phone: + 44 (385) 302 317

Biography: *Industrial and commercial photographer but specializing in architecture and buildings with special emphasis on the food and drinks industry. Main commissions are to the designer and/or architect where the mood and style in particular of an interior needs to be brought out. Has produced work for many well-known clients in the brewing industry and related industries, travelling all over the UK and onto the continent.*

Indoor shots: Multi-level Interior p79, Inn Leisure p81, Pub Restaurant p87, Courage p103, Conference Room p105, Carpet p107, Garden Room p145

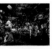
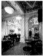
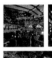
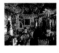

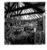

Photographer: **EROS MAURONER**

Studio: ARICI & MAURONER FOTOGRAFI

Address: VIA B. MAGGI 51\B
25124 BRESCIA
ITALY

Telephone: + 39 (30) 22 55 88 AND 24 24 212

Fax: + 39 (30) 22 55 88

Indoor shot: Bedroom p47

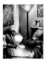

Photographer: **JAY MYRDAL**

Studio: JAM STUDIOS

Address: 11 LONDON MEWS
LONDON W2 1HY
ENGLAND

Telephone: + 44 (1 71) 262 7441

Fax: + 44 (1 71) 262 7476

Mobile Phone: +44 (8 50) 600 963

Biography: *An American living and working in London since the middle '60s, Jay has worked in many areas of photography from editorial through rock and roll to advertising.*

His work remains wide-ranging, but he is best known for special effects and complicated shots; he works on a single image for many days if necessary. An extensive knowledge of practical electronics, computers, software and mathematics is brought into the service of photography when required, and he has a good working relationship with top-quality model makers and post-production houses as well as working closely with third party suppliers. He has recently purchased a powerful electronic retouching system and expects to work more in this medium in the future.

Indoor shots: Four Dalmatians p24/25, Argentaria Banking Floor p100/101, Flying Boards p135

Photographer: **JON PERUGIA**

Address: 38 ARCHER HOUSE
LONDON SW11 3LF
ENGLAND

Telephone: + 44 (1 71) 585 3779

Biography: *With a background in film and television, Jon is largely a self-taught photographer whose approach is as versatile as it is flexible. His work for Time Out Guides in Madrid, Paris and London has required high levels of skill in interiors, still-lifes, portraiture, cityscape/landscape and documentary photography, as well as the ability to improvise and flourish under tight deadlines. His other clients have included restaurants, bars, shops, holiday centres and private portraiture. In addition to travel and commercial photography he is working on documentary projects in London and Greece, and developing a portfolio of yoga photographs.*

Indoor shot: The Engineer p83

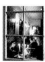

Photographer: **EDWIN RAHARDJO**

Studio: SIGMA STUDIO

Address: JL. KEMANG RAYA NO. 21
KEMANG
JAKARTA 12730
INDONESIA

Telephone: + 62 (21) 719 47 21 AND 799 80 49

Fax: + 62 (21) 799 02 78

BIOGRAPHY: *Born in Jakarta, Indonesia in 1953. Educated in the United States with architectural and interior design background. Started career as professional photographer in 1980. Has worked for more than 800 clients including Merchantile Club, Mandarin Hotel, Panasonic, De Beers Diamond, Nivea, Wella, Toyota, Honda etc. Besides a photo studio, Edwin owns a fine art gallery and a hobby shop.*

Indoor shot: Mandarin Hotel, Jakarta p77

Photographer: **GEORGE SOLOMONIDES**

Address: 77 SUGDEN ROAD
LONDON SW11 5ED
ENGLAND

Telephone: + 44 (1 71) 223 7885

Fax: + 44 (8 60) 645 573

Biography: *Specialist in architecture/interior and landscape work on location and automotive/fabric/furniture work in the studio.*

Indoor shots: Living Room p20/21, Mosque Ceiling p119

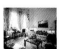

Photographer: **KENICHI URA**

Studio: JIB CO

Address: 7-4-7 HIGASHI-NAKAHAMA
JOTO-KU OSAKA
JAPAN

Telephone: + 81 (6) 968 5454

Fax: + 81 (6) 963 3172

Biography: *1945; born in Osaka. 1968; member of Hidano photographer office. 1971; freelance. 1987; established JIB Co.*

Indoor shots: Matsushita Catalogue p129, Yamaha Piano Silent Series p131

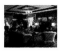

Photographer: **BRUNO VEZZOLI & CARLO GESSAGA**

Studio: IKB FOTOGRAFIA

Address: VIA PAOLO BORGHI 3/B
22060 CUCCIAGO (CO)
ITALY

Telephone: + 39 (31) 787 675

Fax: + 39 (31) 787 473

Biography: *In their 450 square metre studio they shoot for a wide range of clients, for editorial and advertising, but overall they specialize in furniture shots – at Brianza, close to Milan, they are close to the most important furniture producers in the world. They build sets, making "rooms to measure" to suit clients, often working on 3 or 4 sets simultaneously. They light mainly with tungsten and shoot on 4x5 inch and 5x7 inch.*

Indoor shot: Riva 3 p38/39

Photographer: **BRENDAN A. WALKER**

Studio: A/A

Address: 82A ST. JOHN'S AVENUE
LONDON NW10 4EG
ENGLAND

Telephone: + 44 (81) 961 3799

Biography: *Studied art and design and fine art/painting before going on to complete a Higher National Diploma in photography in June 1995. During that time he assisted many London-based photographers. He has exhibited work at The Custard Factory in London and is now (1995) working principally as an assistant as well as accepting his own commissions.*

Indoor shots: The Bentall Centre p89, Townley Hall p96/97

 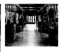 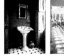 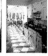

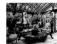 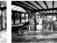

Photographer: **DAVID N. WATTS A.B.I.P.P.**

Studio: THOMAS NEILE PHOTOGRAPHERS

Address: JOSEPH WILSON INDUSTRIAL ESTATE
WHITSTABLE
KENT CT5 3EB
ENGLAND

Telephone: + 44 (1 227) 272 650

Fax: + 44 (1 227) 770 233

Biography: *David Watts studied photography at the London Polytechnic and after three years started his own business in 1966, specializing in industrial and commercial photography. The business now runs two large studios and is backed by its own in-house colour laboratory. Work ranges from cars to computer chips.*
Indoor shots: The Marriott Kitchen p120/121, The Corona, Canterbury Cathedral p141

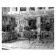

Photographer: **QUINTIN WRIGHT**

Studio: INSIDE OUT

Address: 45 PENROSE STREET
LONDON SE17 3DW
ENGLAND

Telephone: + 44 (1 71) 277 4955

Pager: + 44 (1 459) 129 412

Biography: *After seven years in the Parachute Regiment, Quintin Wright switched from destruction to creation: he realized that he was growing increasingly fascinated by the way that light reveals shape and form. He is now a photographer and has specialized in architectural interiors and exteriors since 1989; the studio name "Inside Out" sums up his work very well.*
Indoor shots: Bedmaking p45, Kitchen/Conservatory p63, Billiard Room p73, Ely Cathedral p109, Quintin Wright p124/125, Beauty Parlour p137, Office p143, Conservatory p147, Conservatory/Dining Room p149, Pool p153

ACKNOWLEDGMENTS

First and foremost, we must thank all the photographers who gave so generously of pictures, information and time. We hope we have stayed faithful to your intentions, and we hope you like the book, despite the inevitable errors which have crept in. It would be invidious to single out individuals, but it is an intriguing footnote that the best photographers were often the most relaxed, helpful and indeed enthusiastic about the Pro-Lighting series.

We must also thank Christopher Bouladon and his colleagues in Switzerland, and of course Brian Morris who invented the whole idea for the series: and in Britain, we owe a particular debt to Colin Glanfield, who was the proverbial "ever present help in time of trouble".

The manufacturers and distributors who made equipment available for the lighting pictures at the beginning of the book deserve our thanks too: Photon Beard, Strobex and Linhof and Professional Sales (UK importers of Hensel flash). And finally, we would like to thank Chris Summers, whose willingness to make reference to prints at odd hours made it much easier for us to keep track of the large numbers of pictures which crossed our desks.